Cartoons for Religious Stained Glass 2006-2008

by Mary Khazak Grant

Copyright © 2012 by Mary K. Grant
All rights reserved. This book or any portion thereof
may not be reproduced or used in any manner whatsoever
without the express written permission of the publisher
except for the use of approved images in a book review.

Printed in the United States of America

First Printing, 2012

ISBN:
978-1-105-61473-6

Lulu.com Publishers

www.Lulu.com

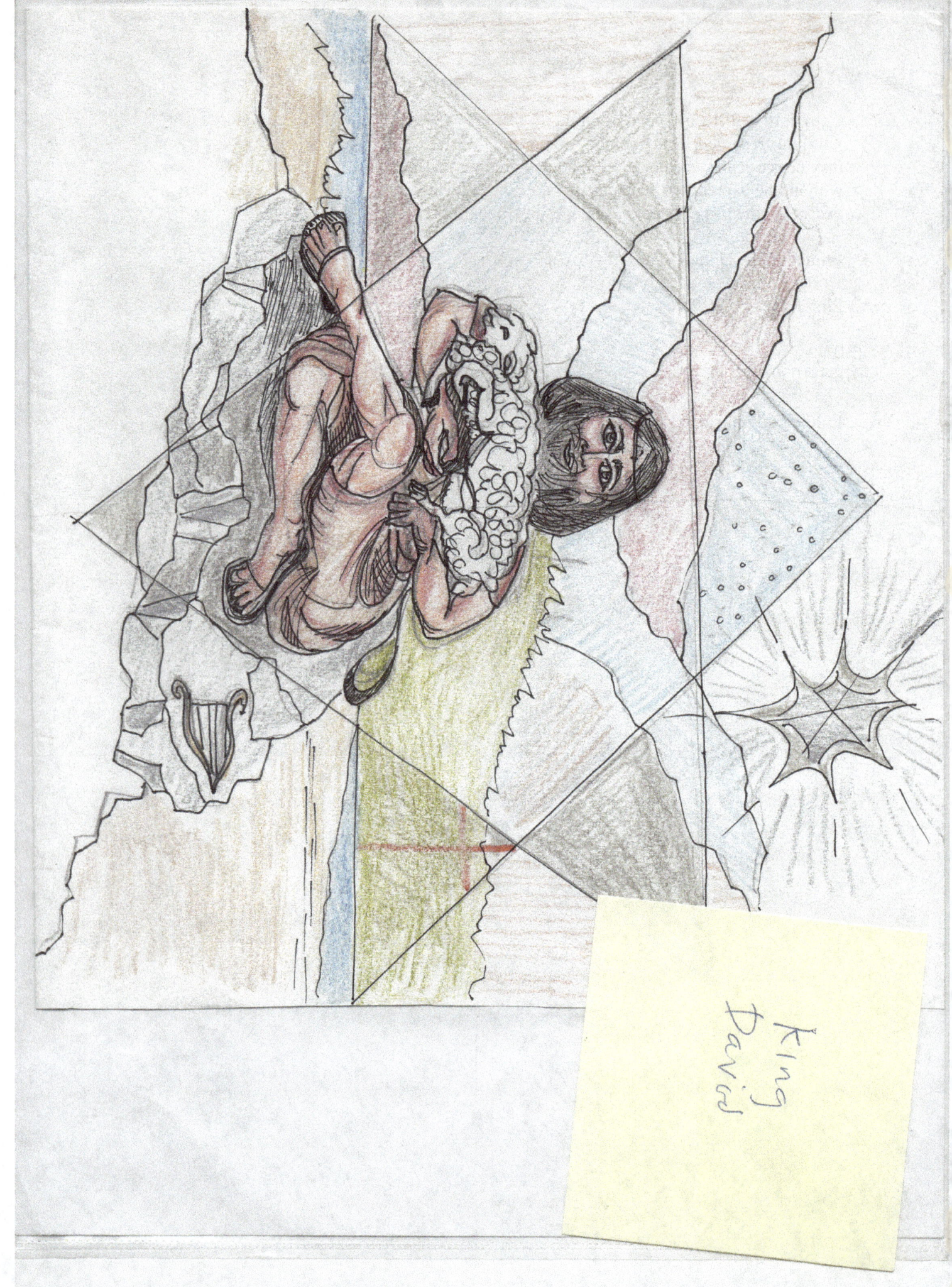

King David

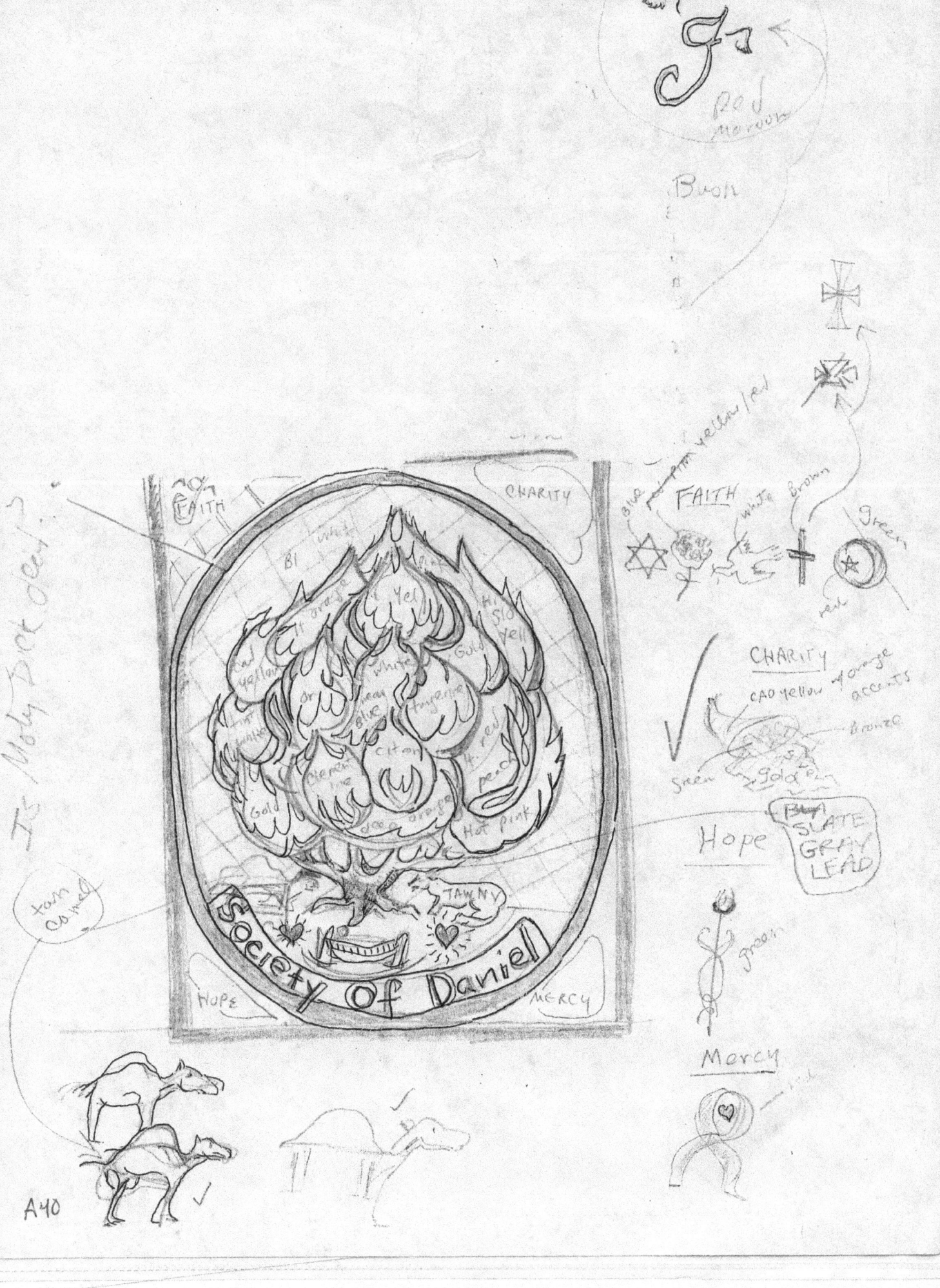

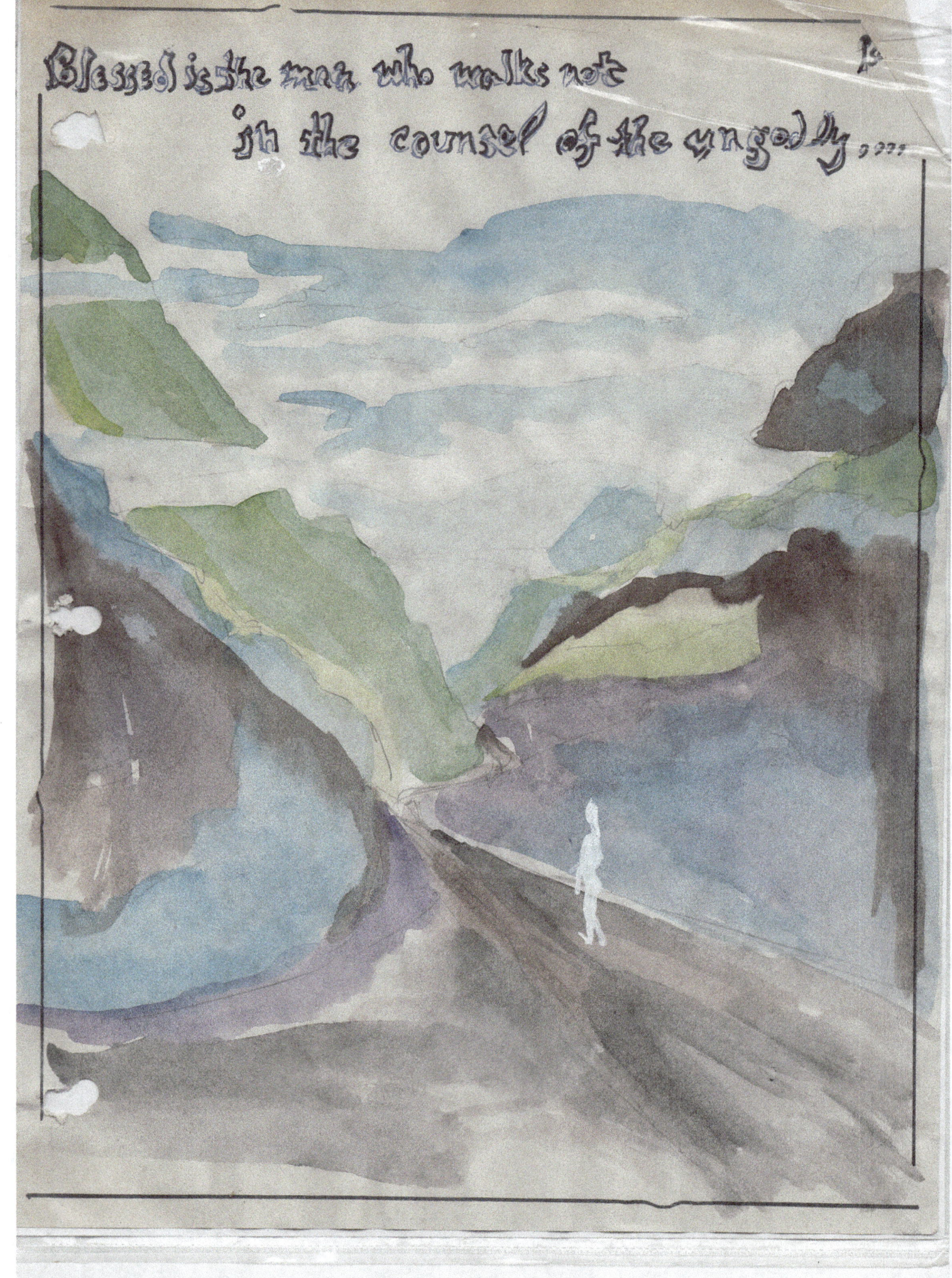

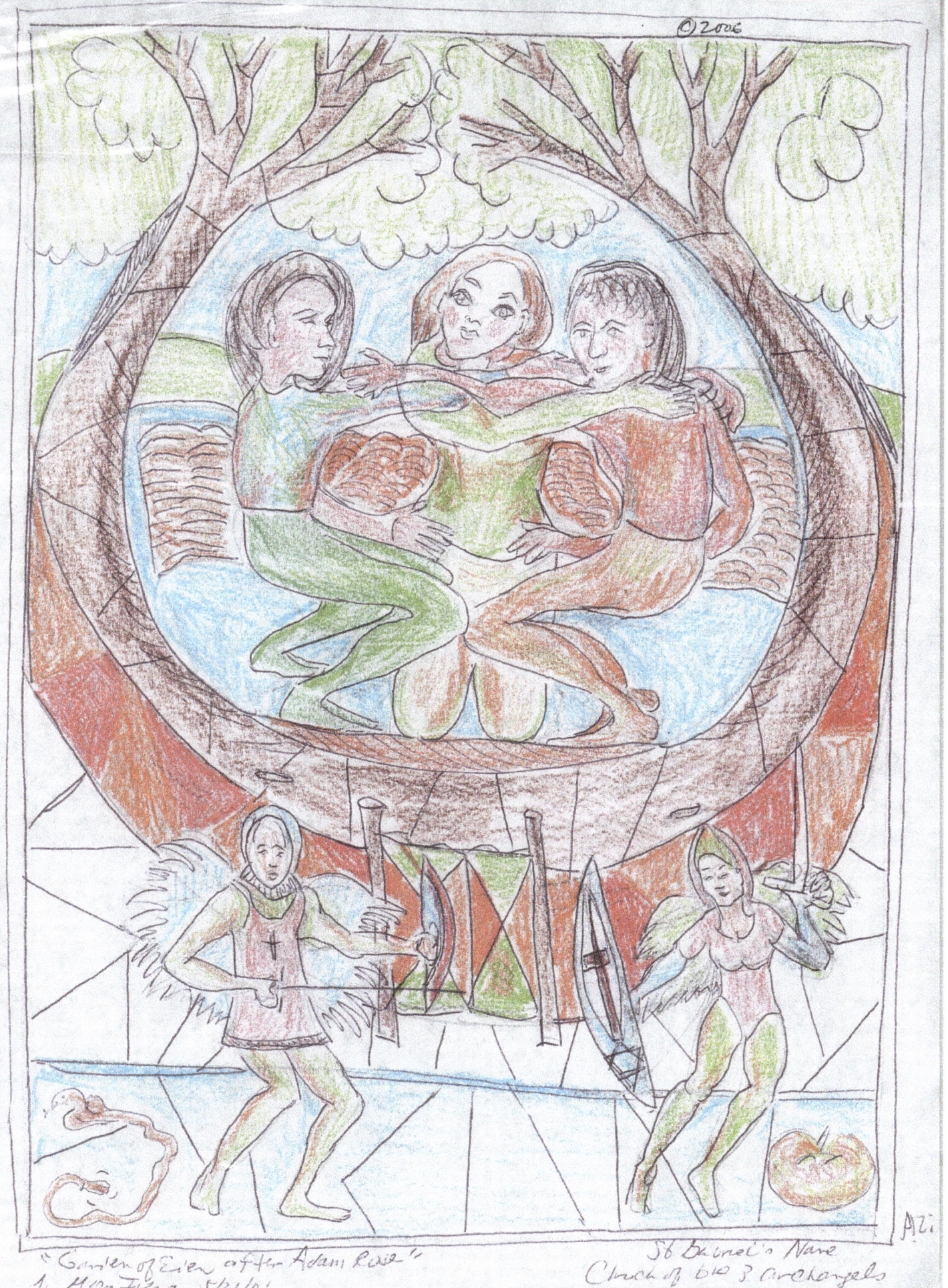

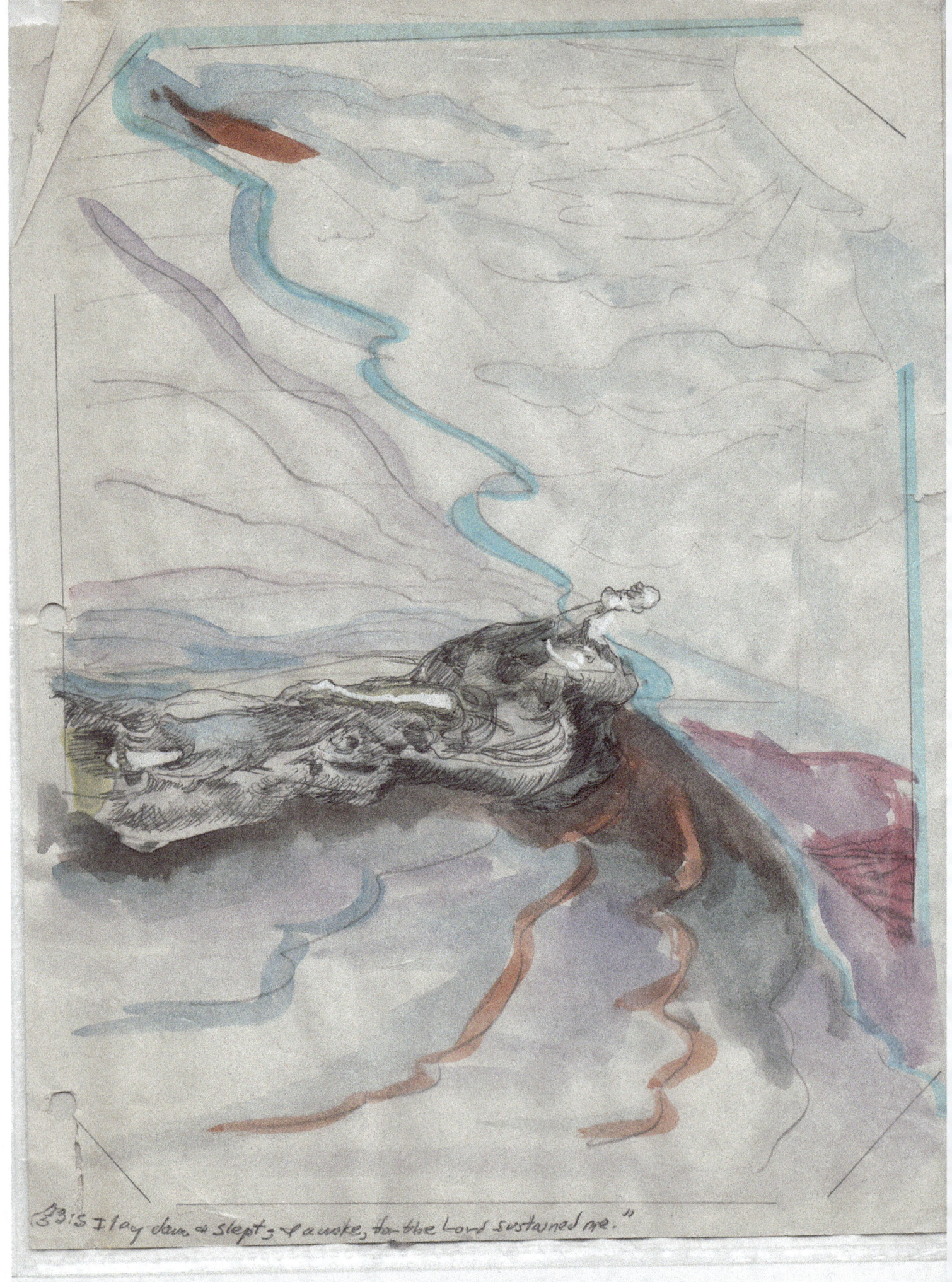

3:5 I lay down & slept; & I awoke, for the Lord sustained me."

"Kiss the Son, lest he be angry," and you perish in the way...."
 psalm 2:1

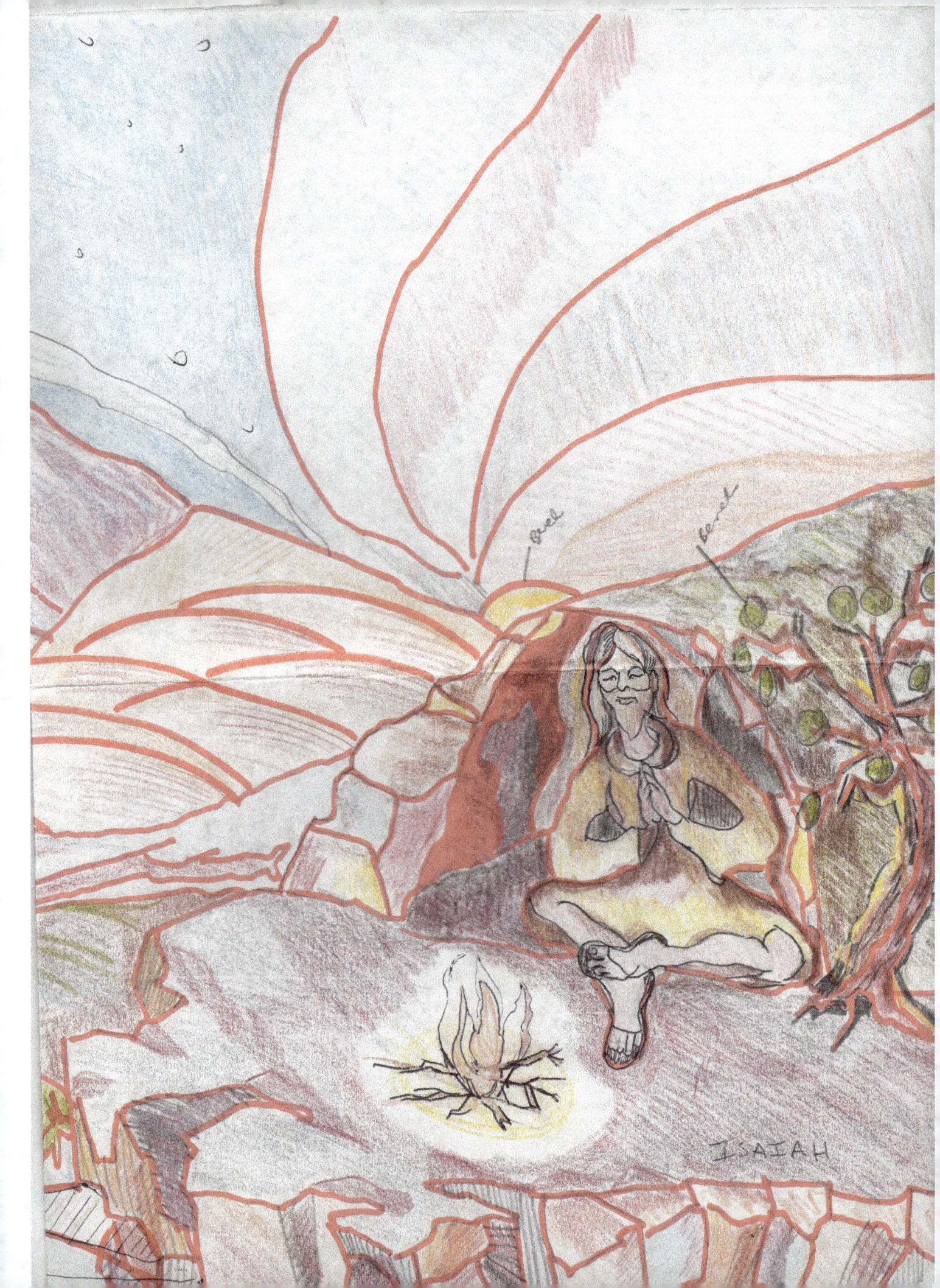

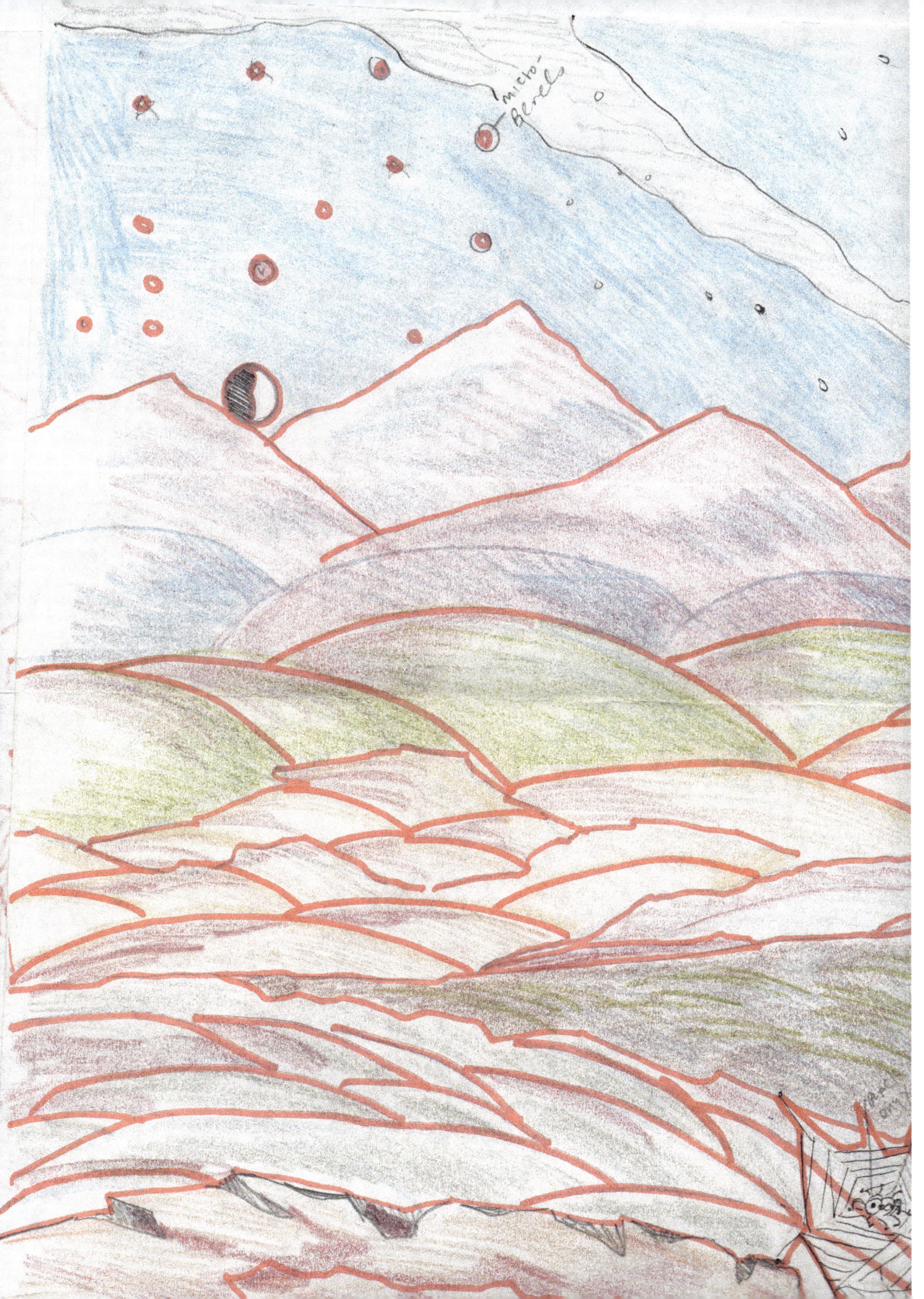

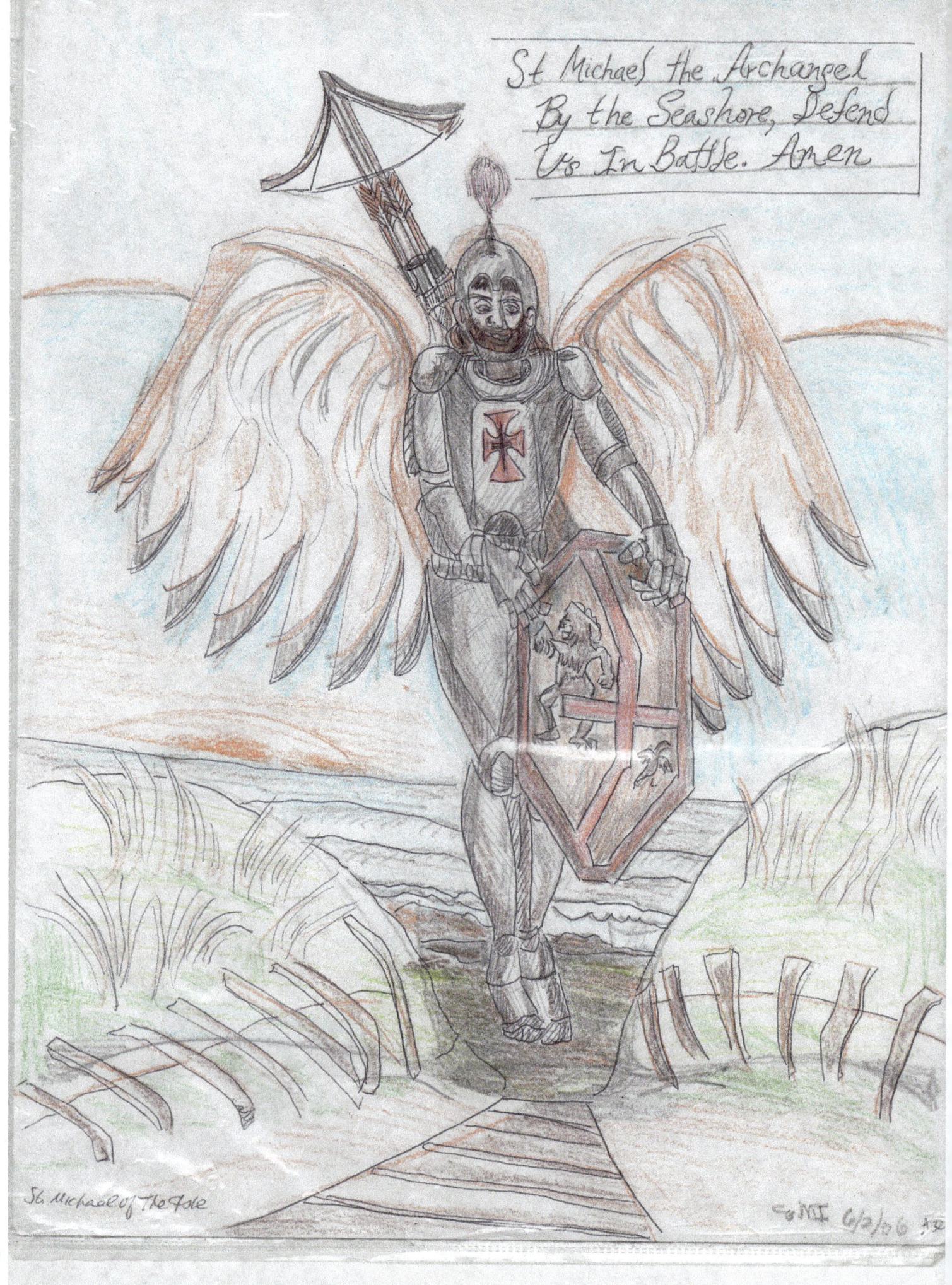

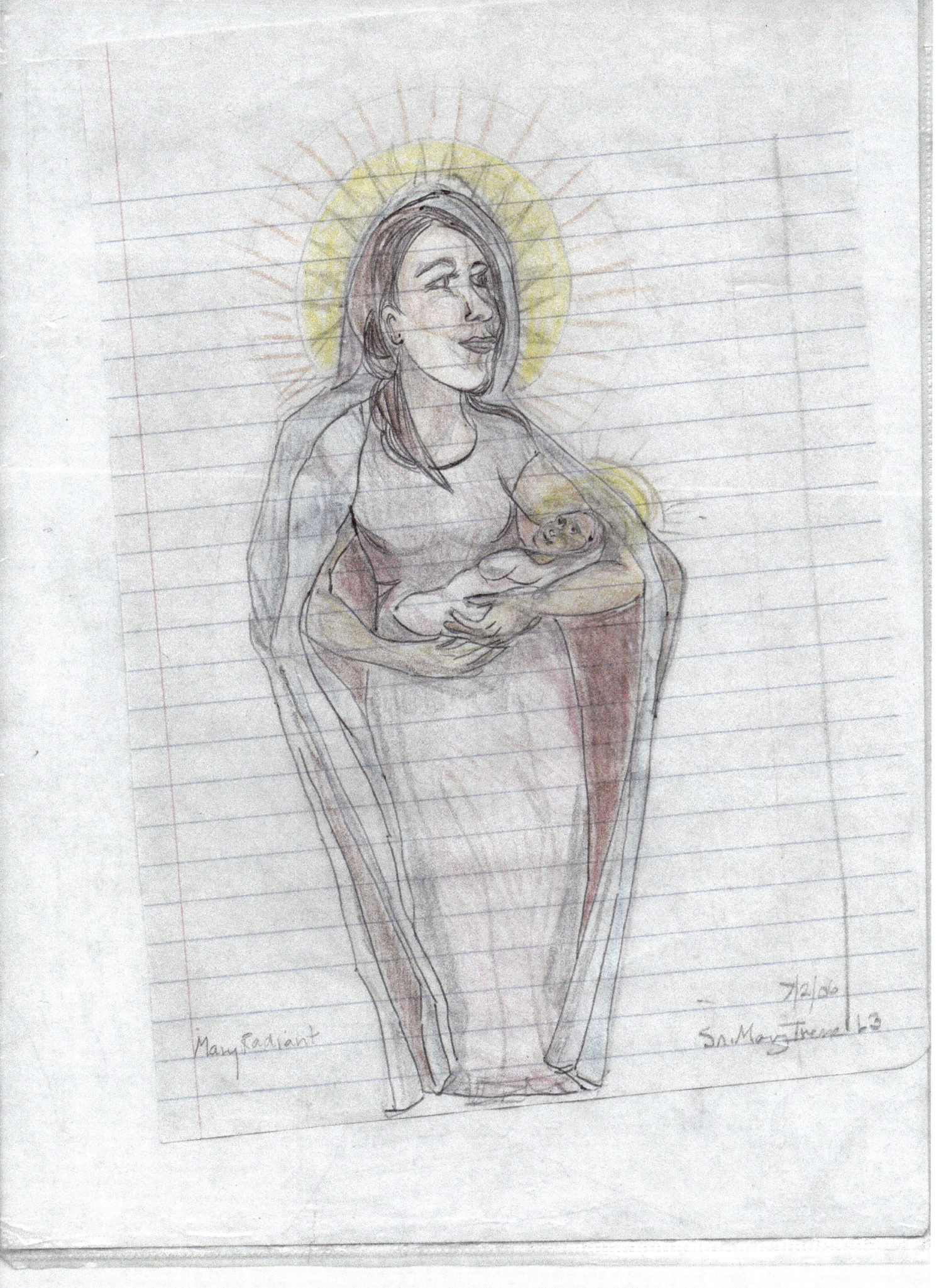

Mary Radiant

7/2/06
Sr. Mary Therese '63

© 2006

Luke 4

"And they worshipped Him, and returned to Jerusalem with great joy."

Any Proceeds to Sanctuary of Dan Society Ads Endowment
prints, glass objects, photos

Quadtych 4 Apostles Stained Glass — Mary Irene © bottom left

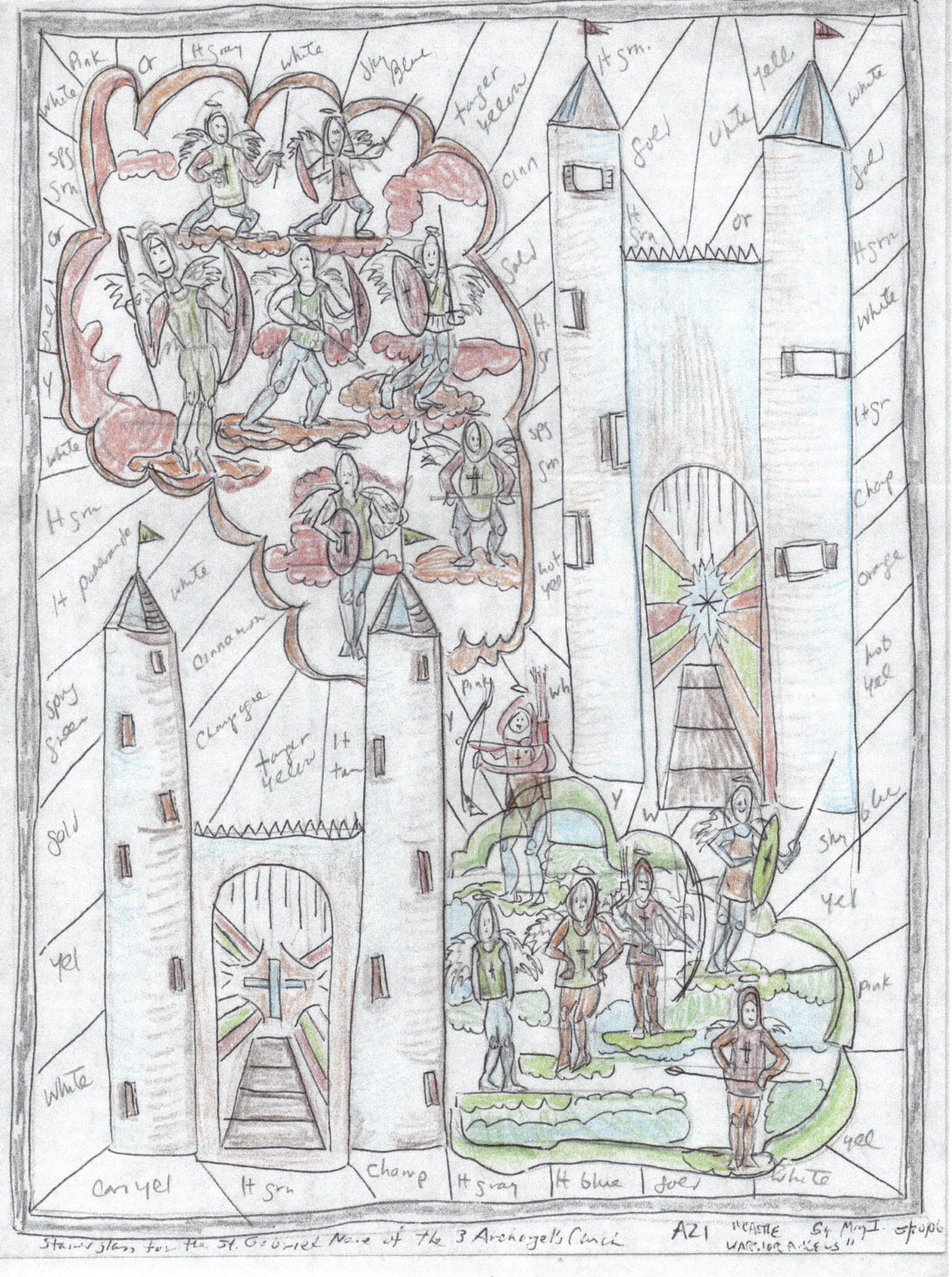

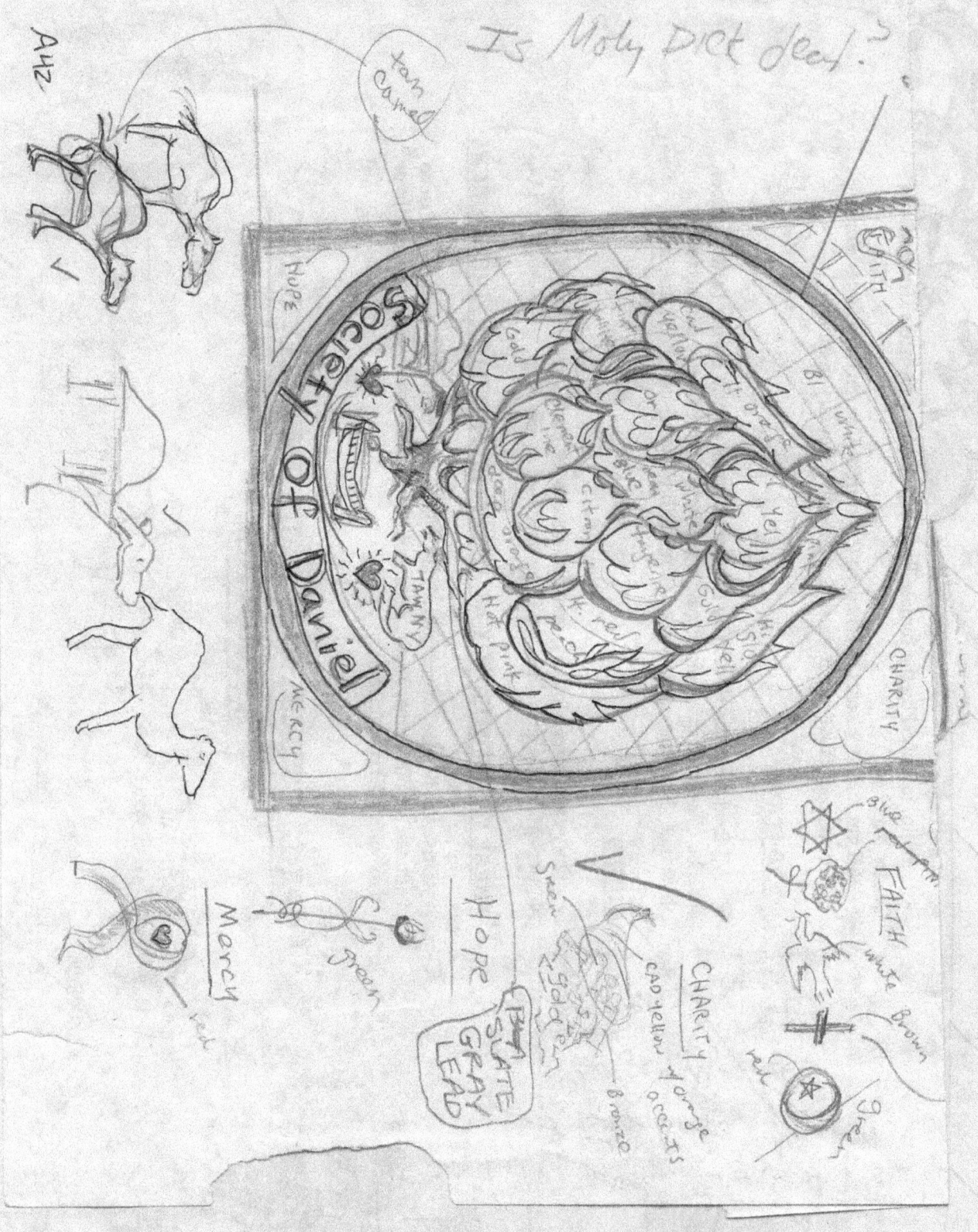

Raphael ר

Michael מ

Gavriel ג

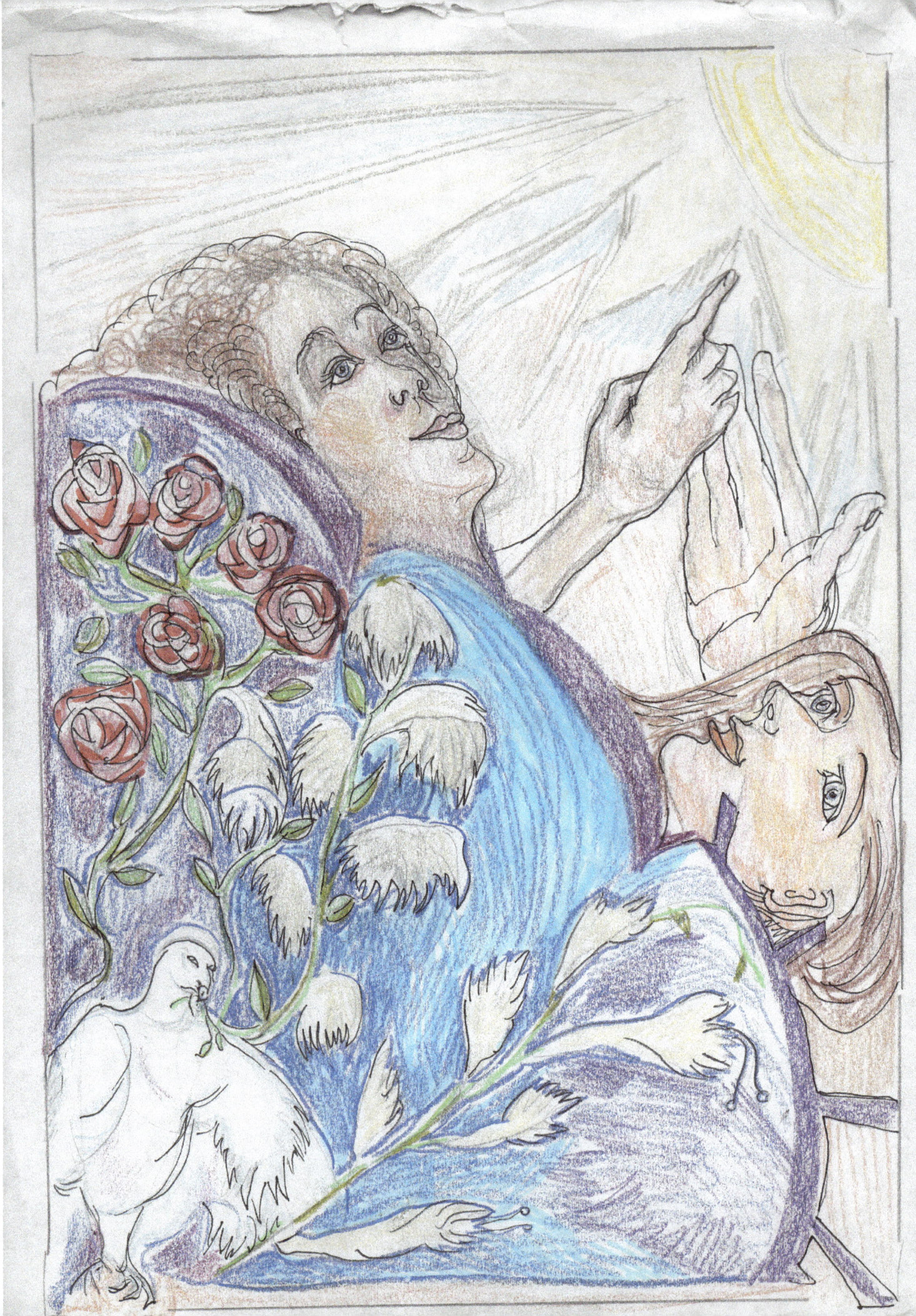

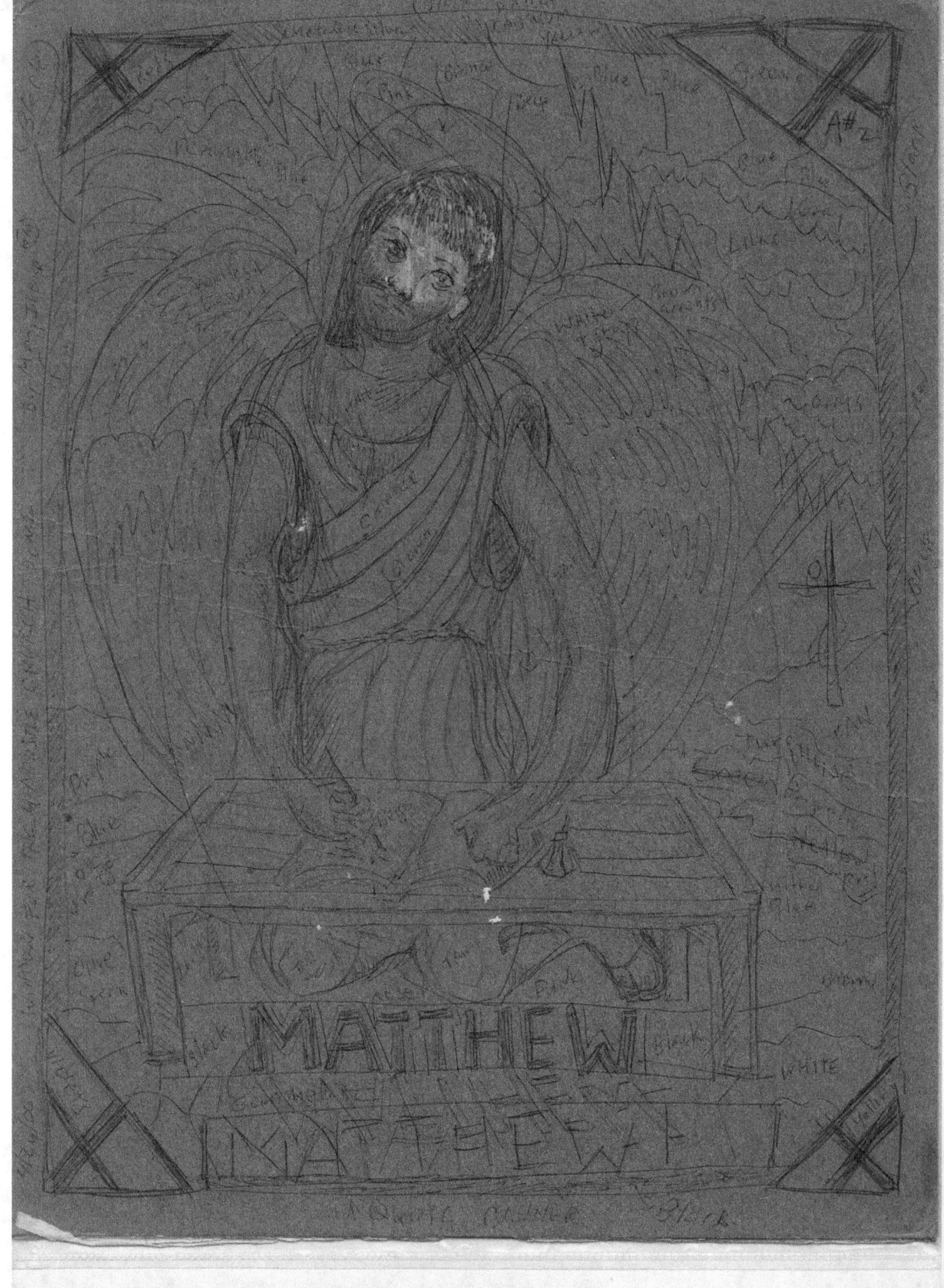

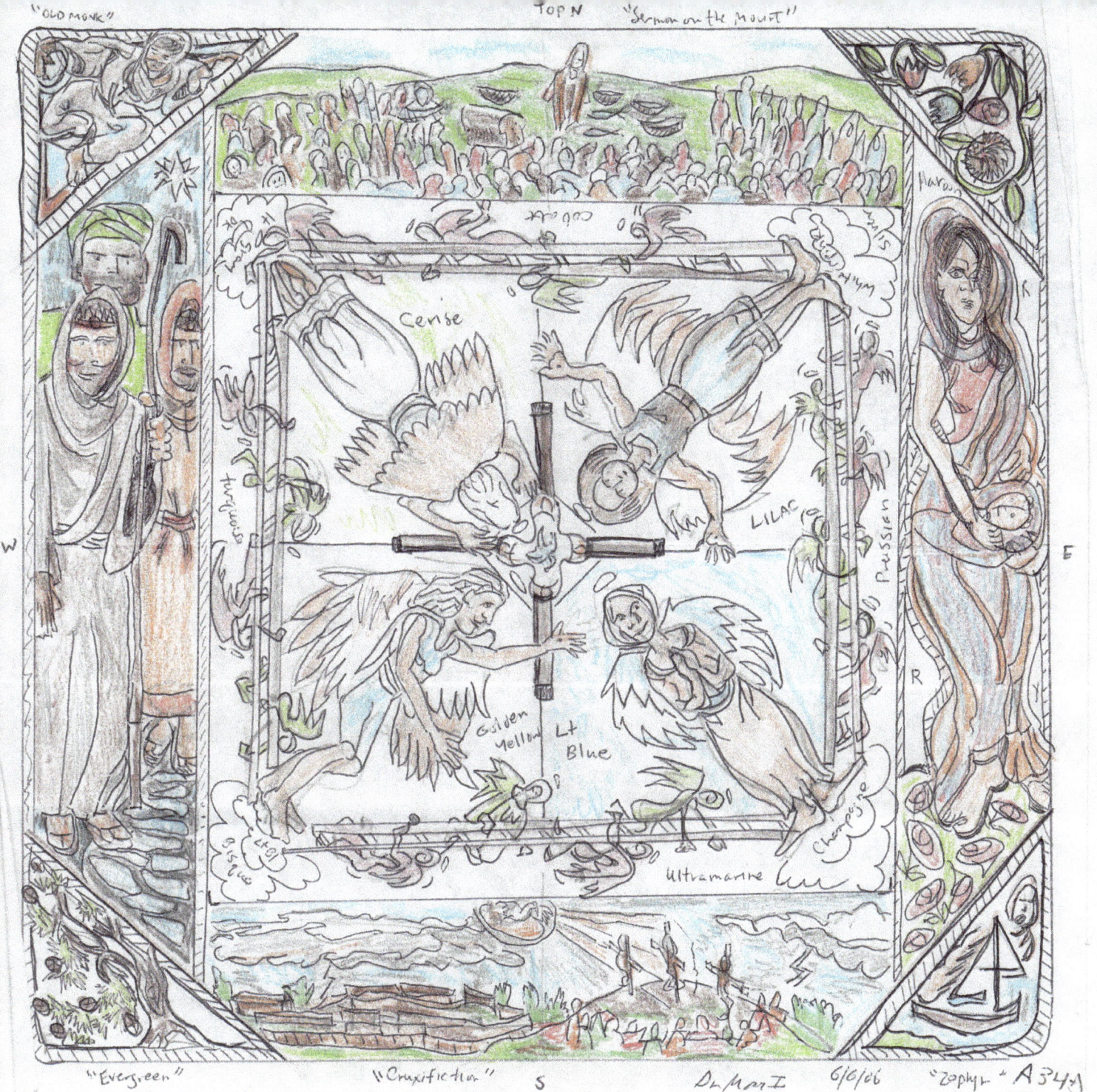

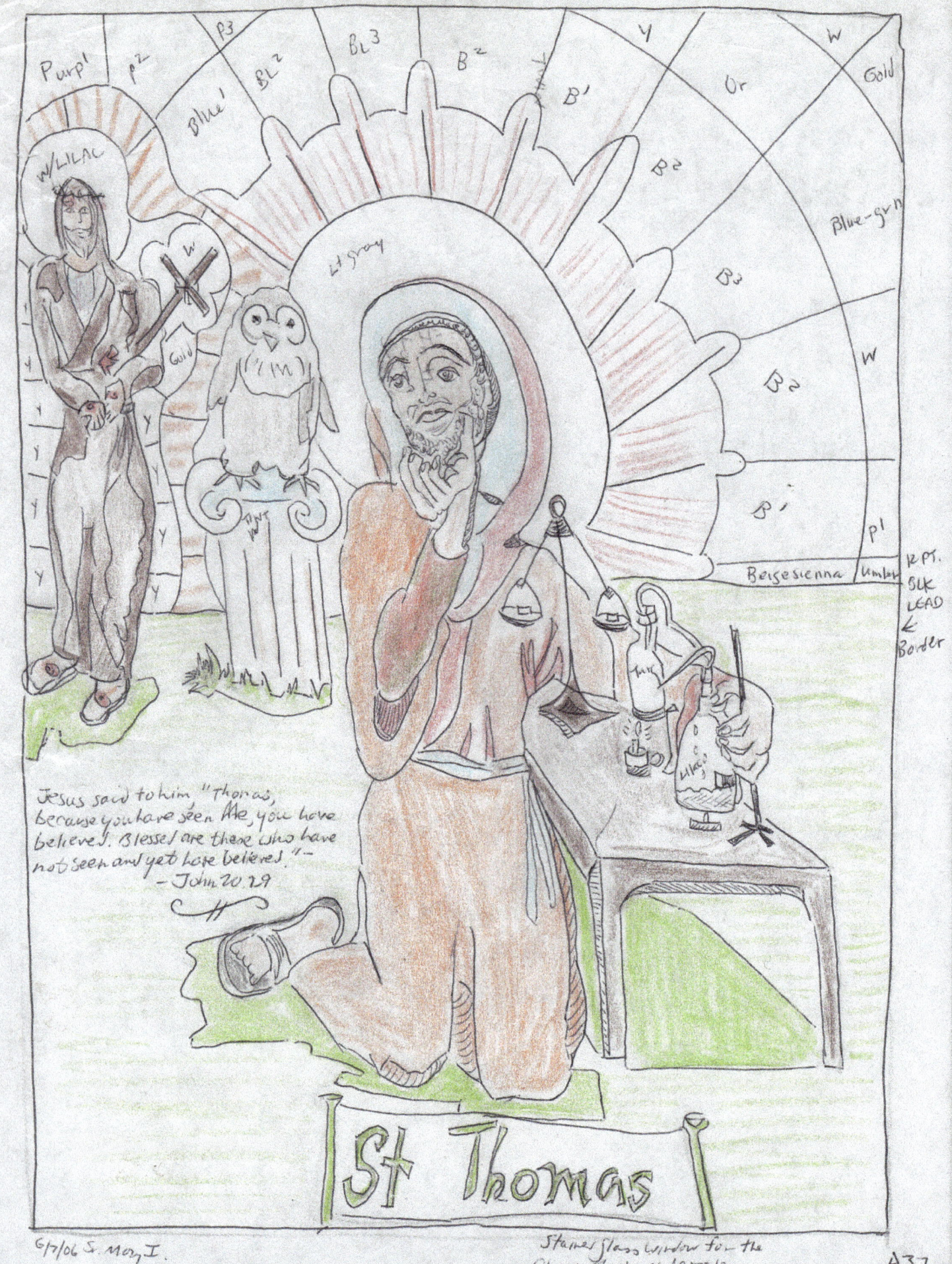

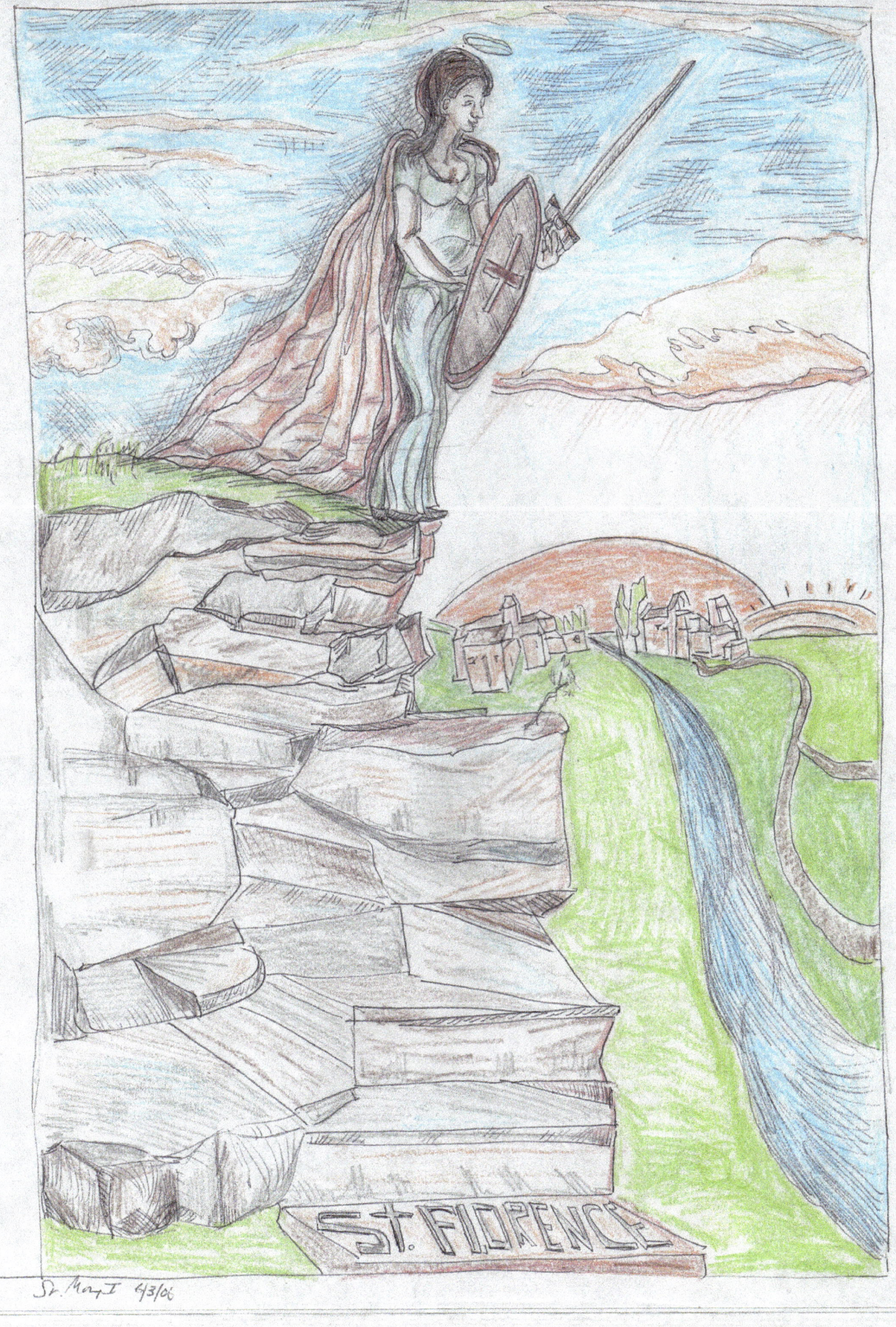

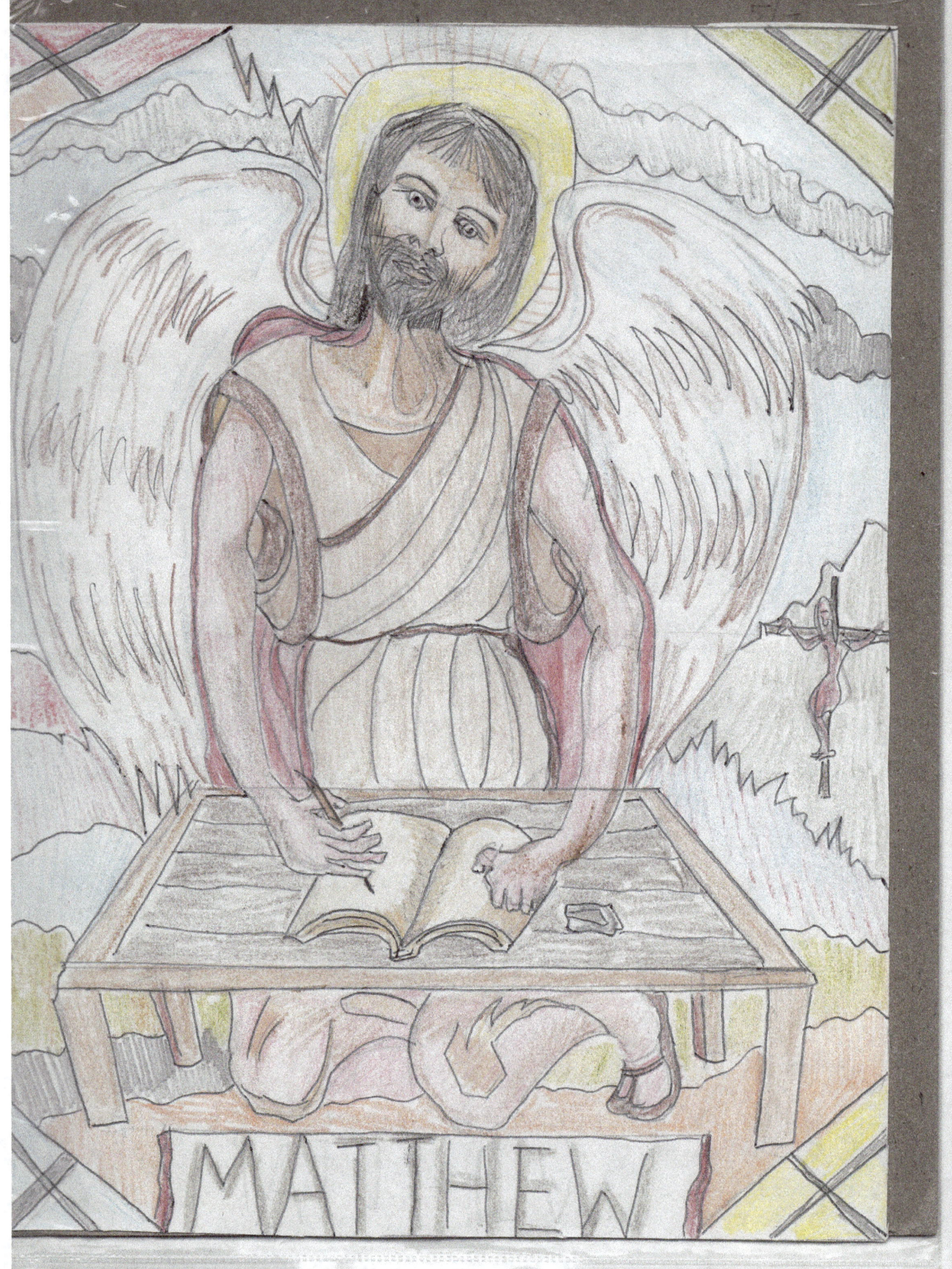

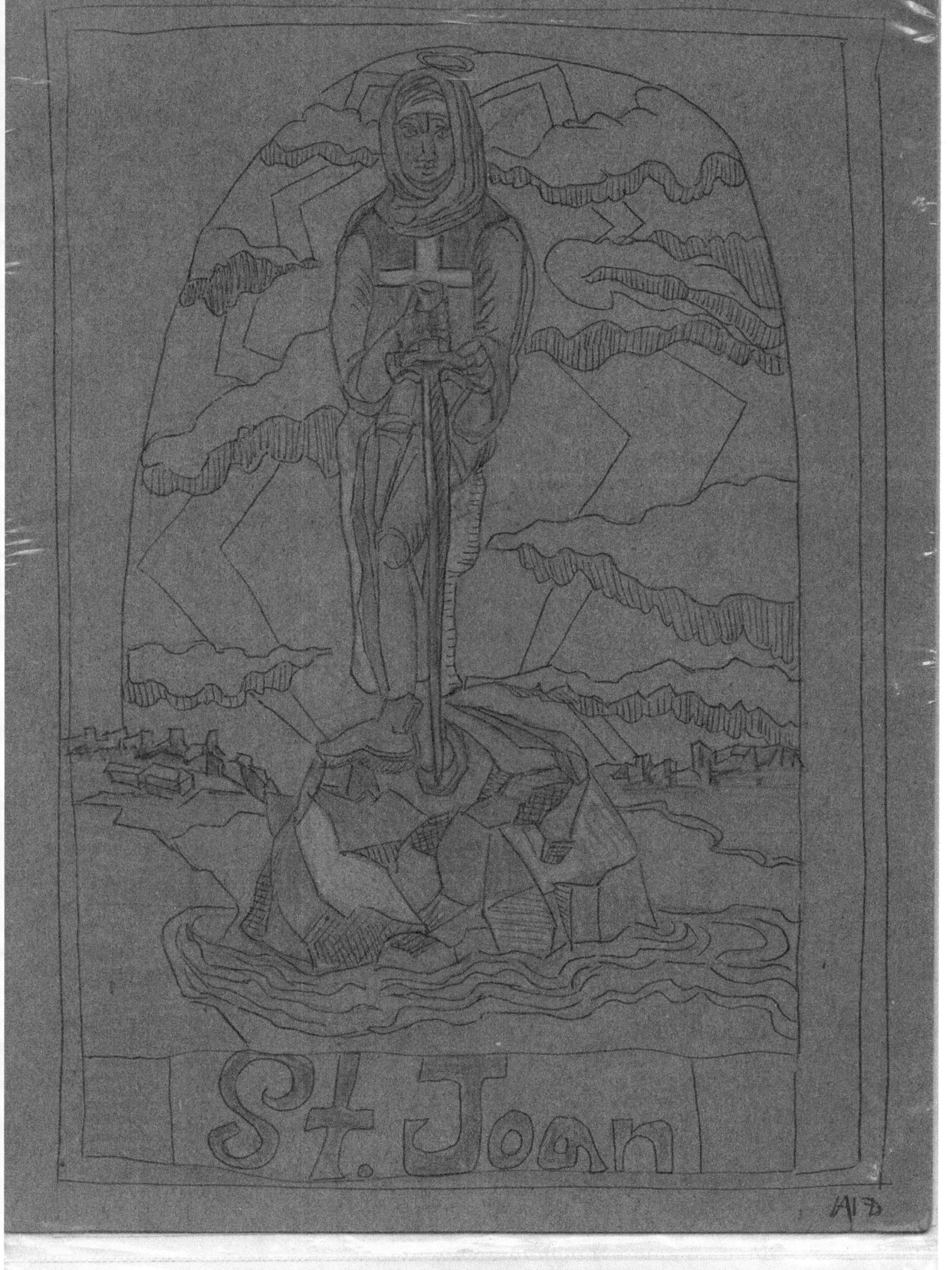

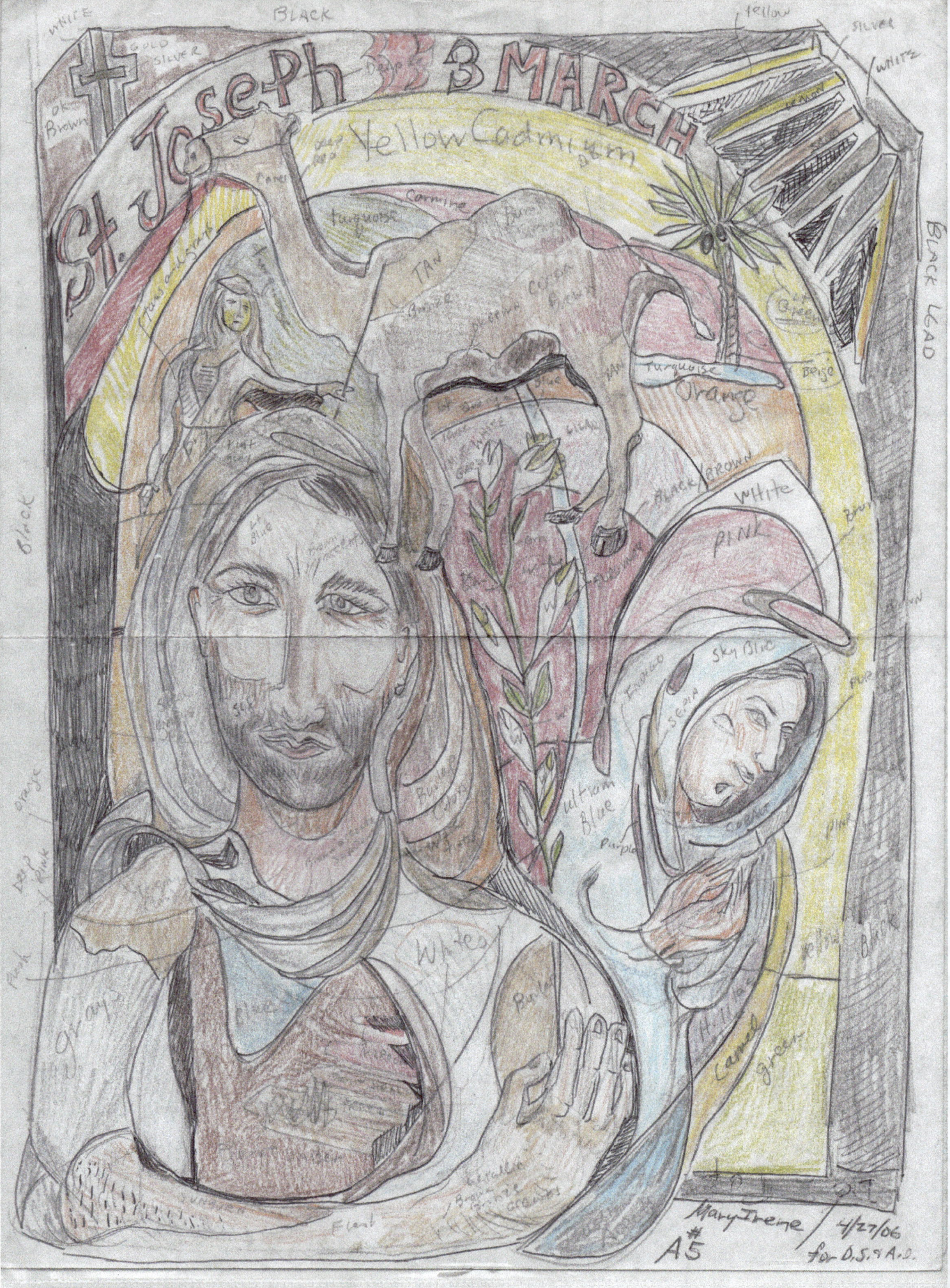

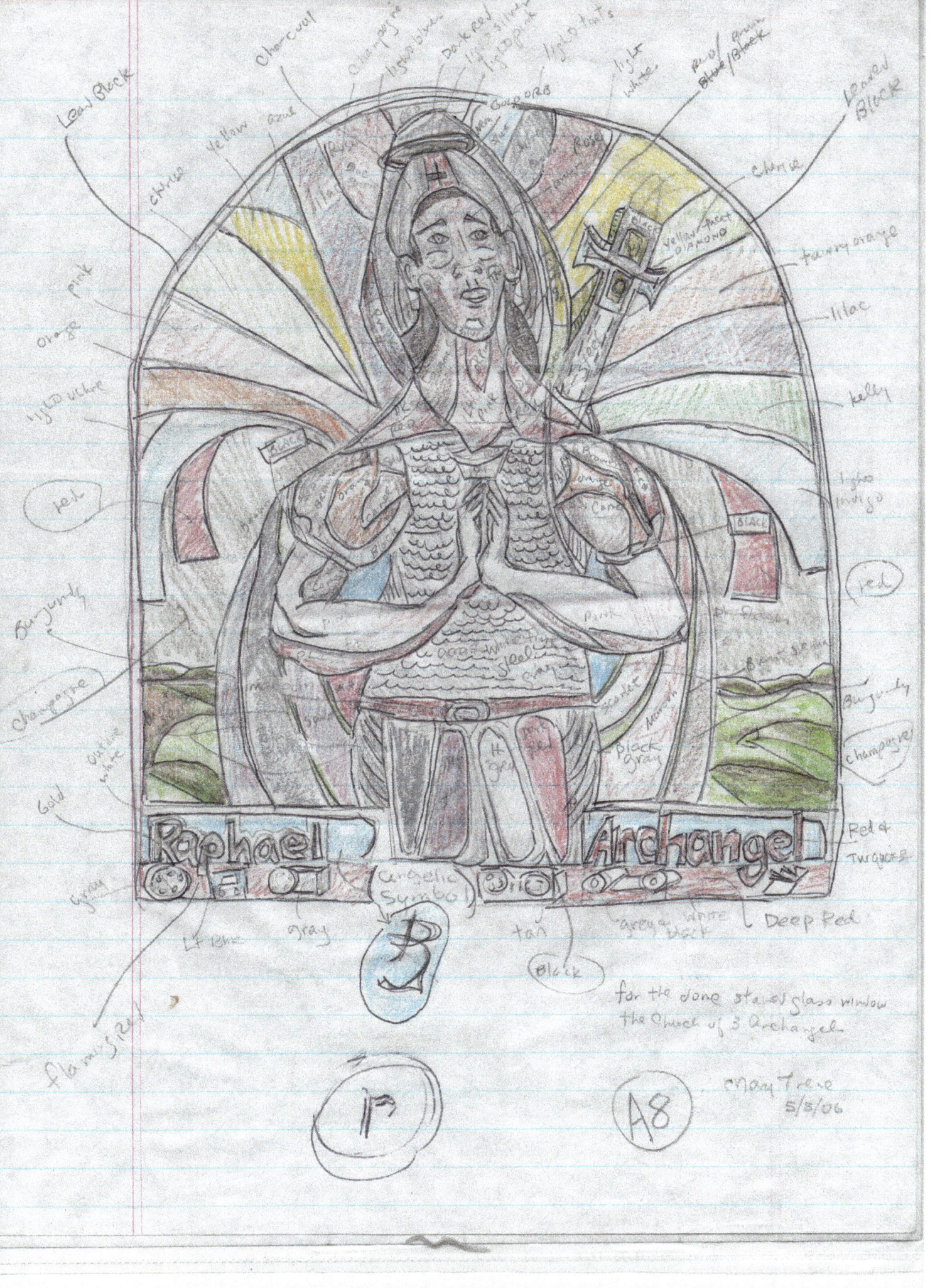

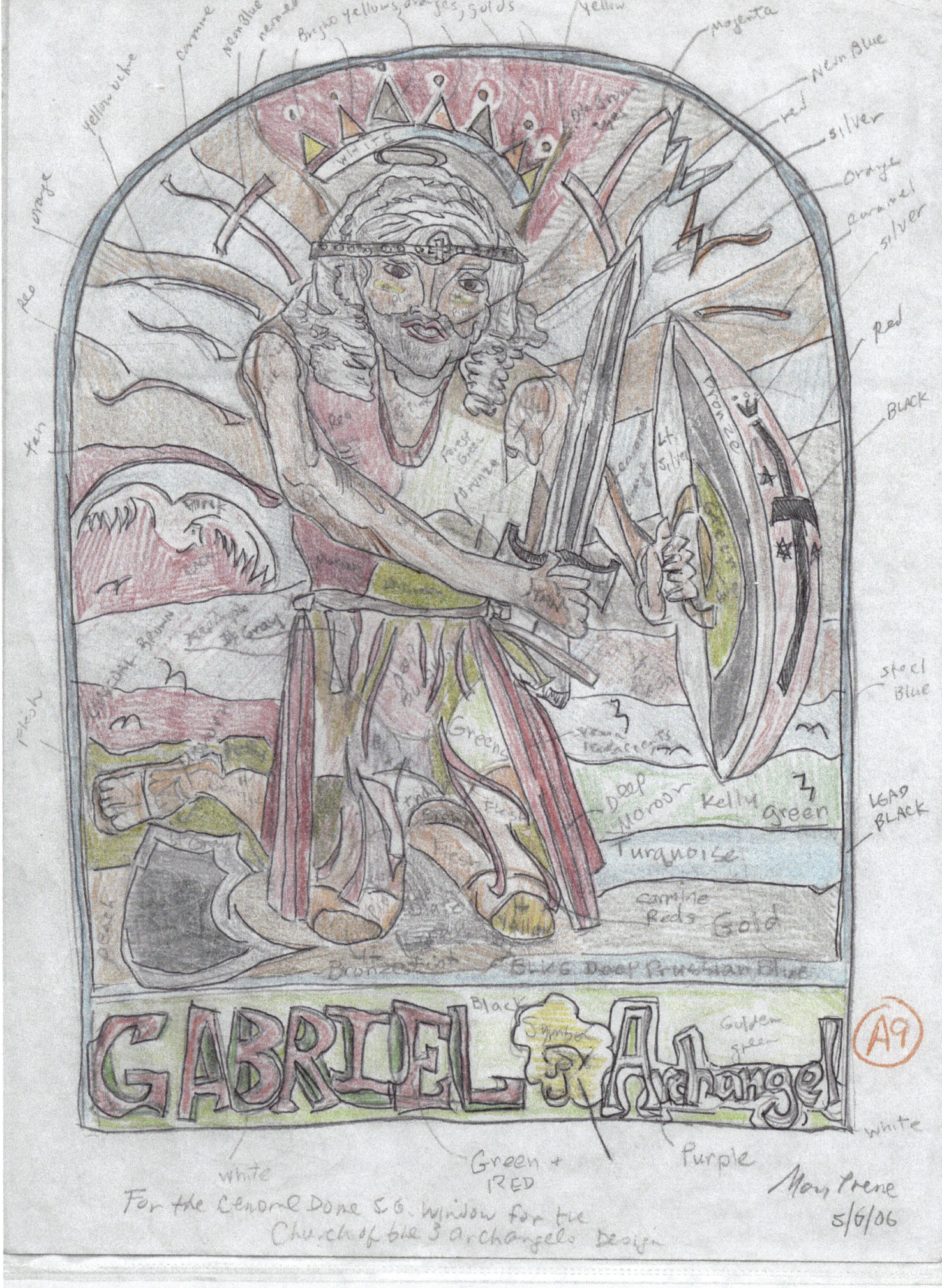

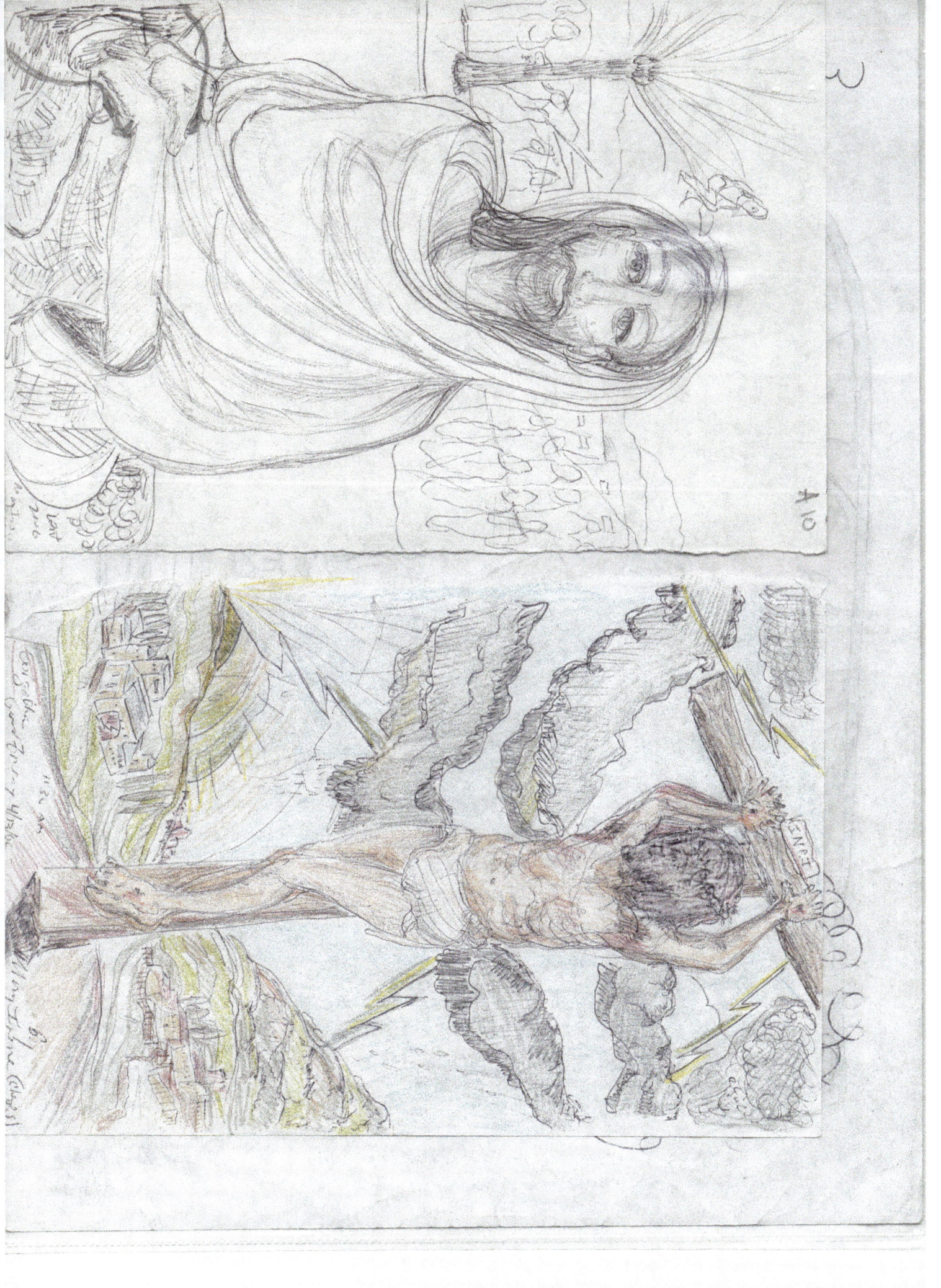

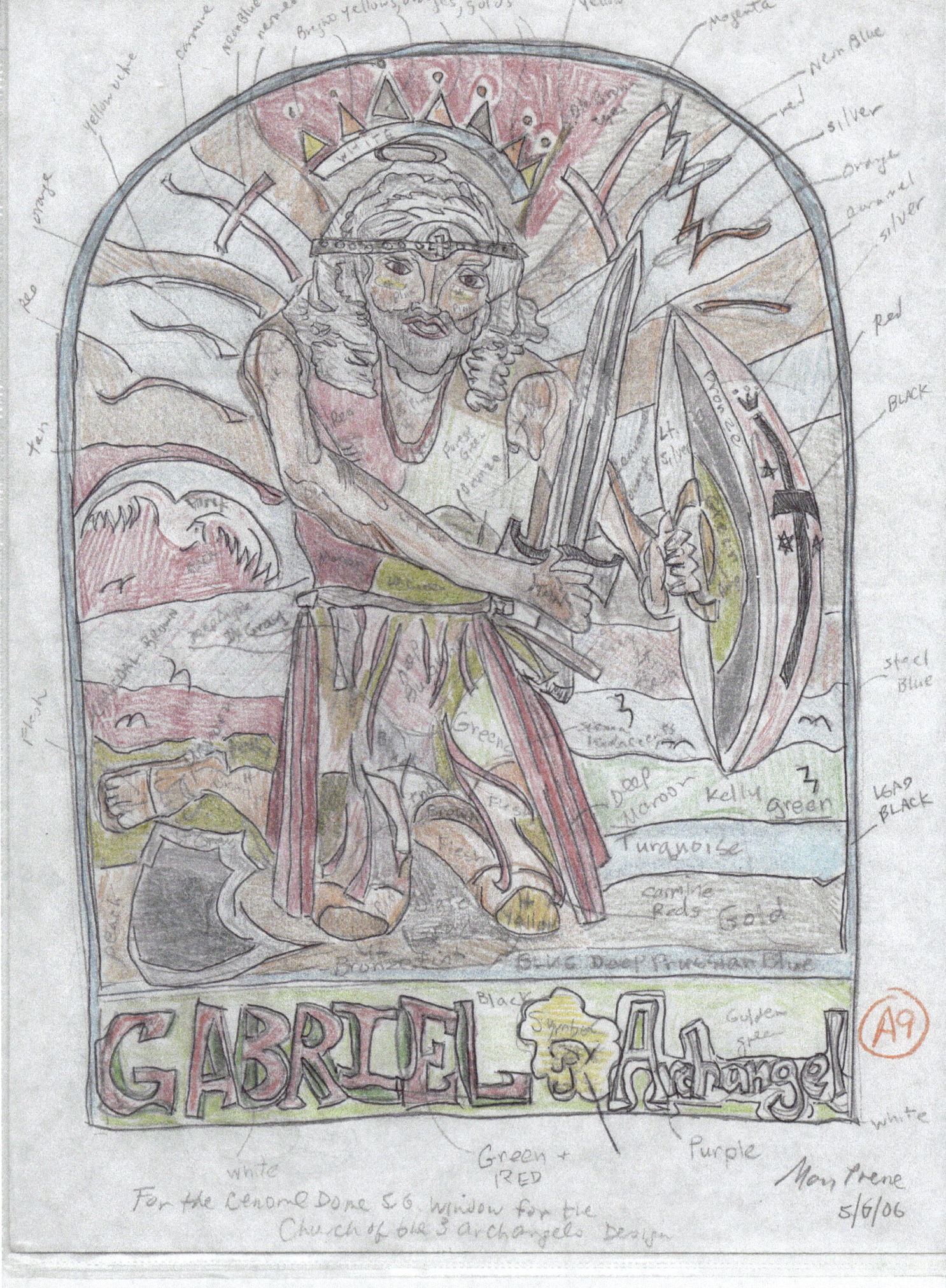

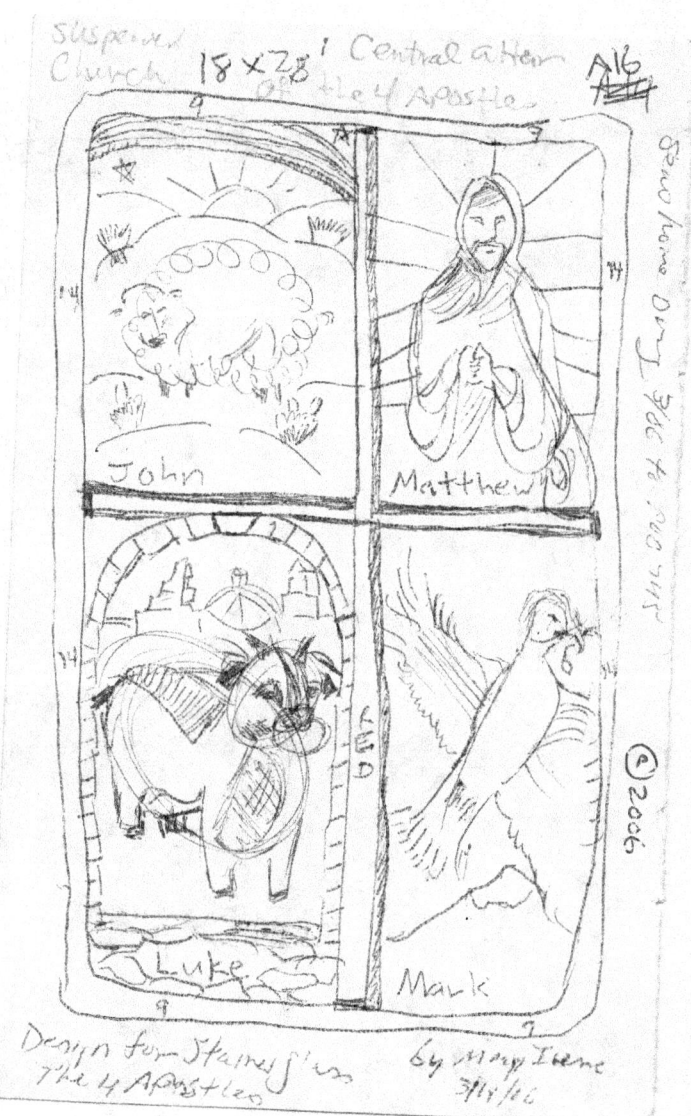

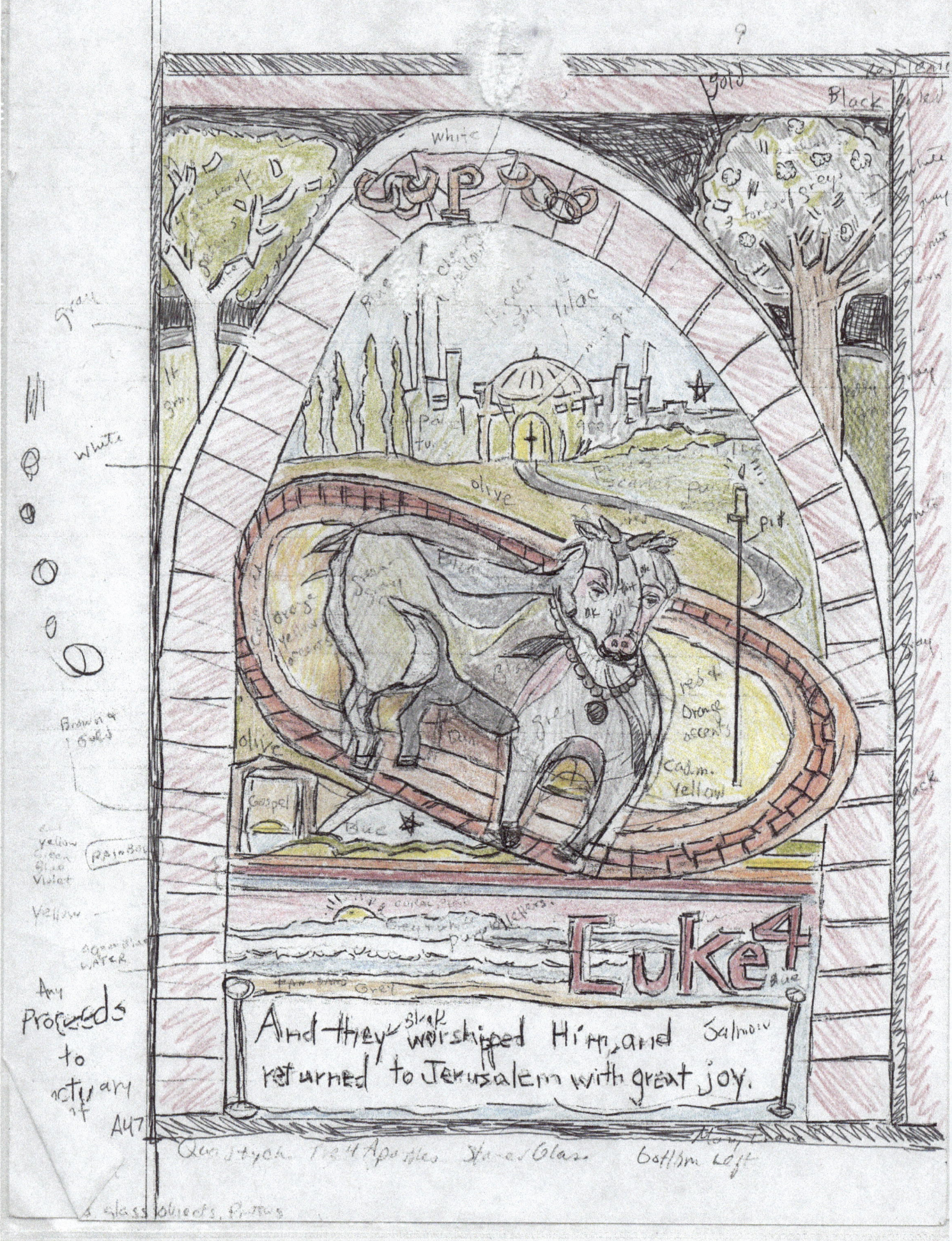

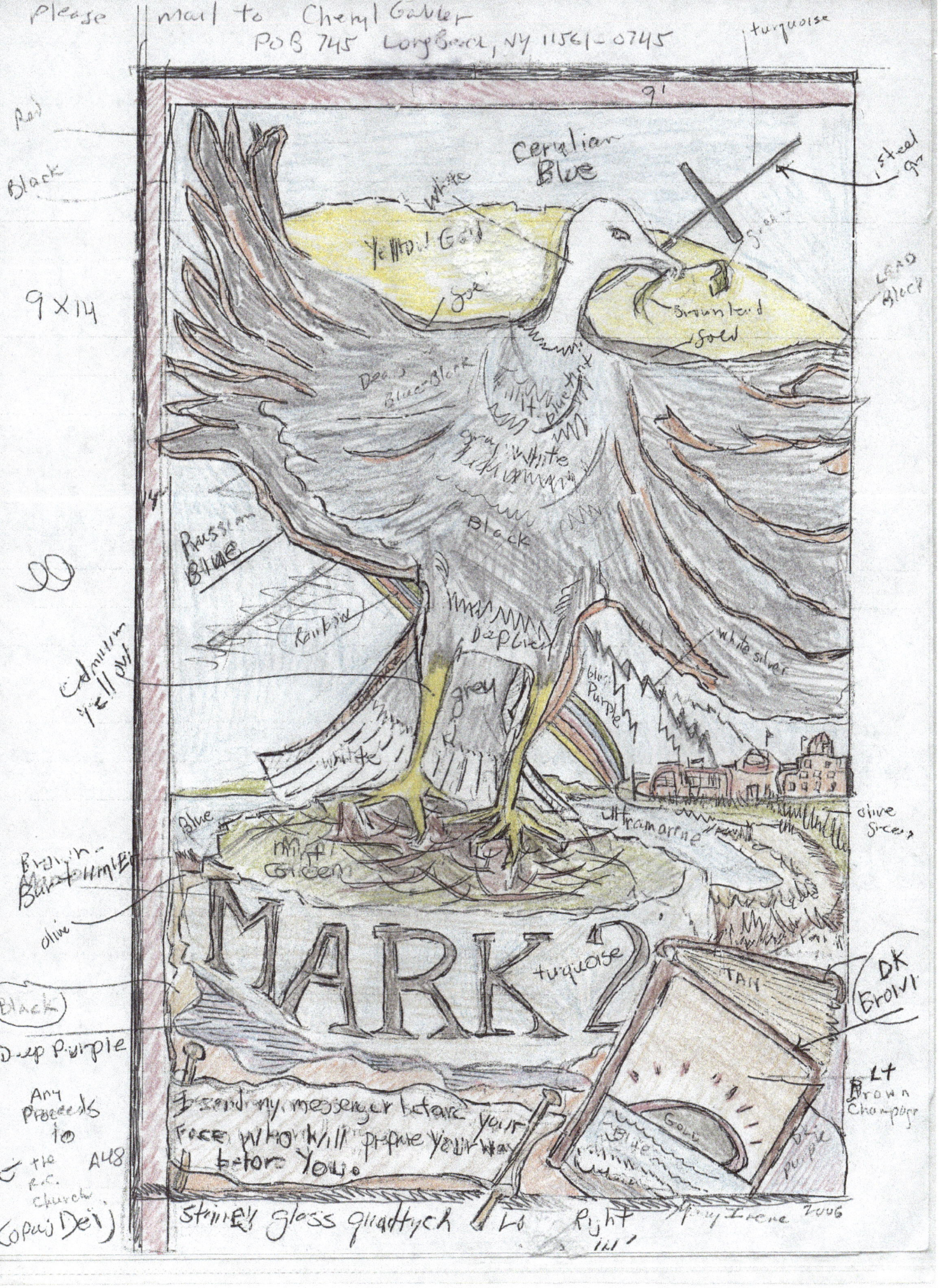

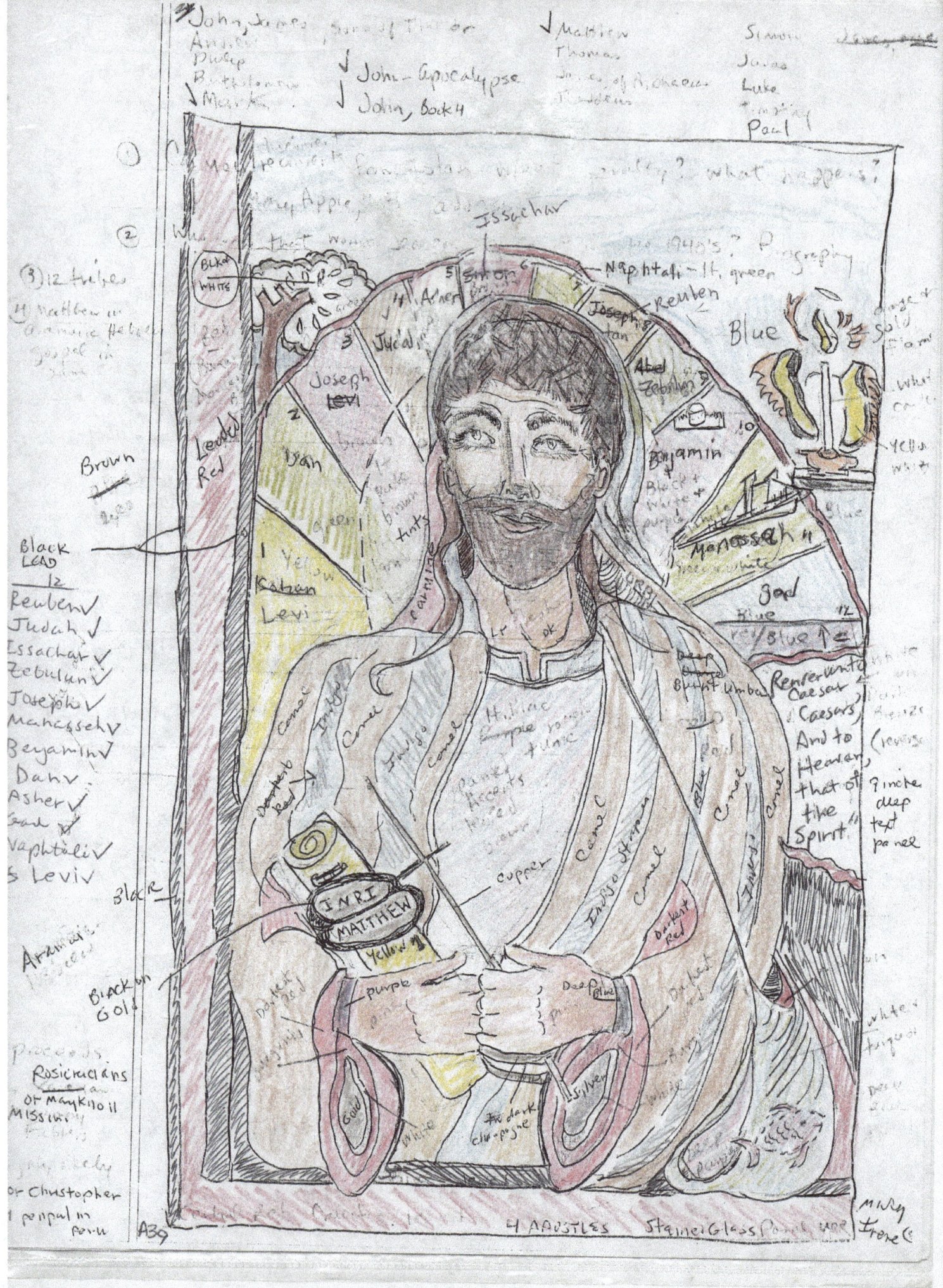

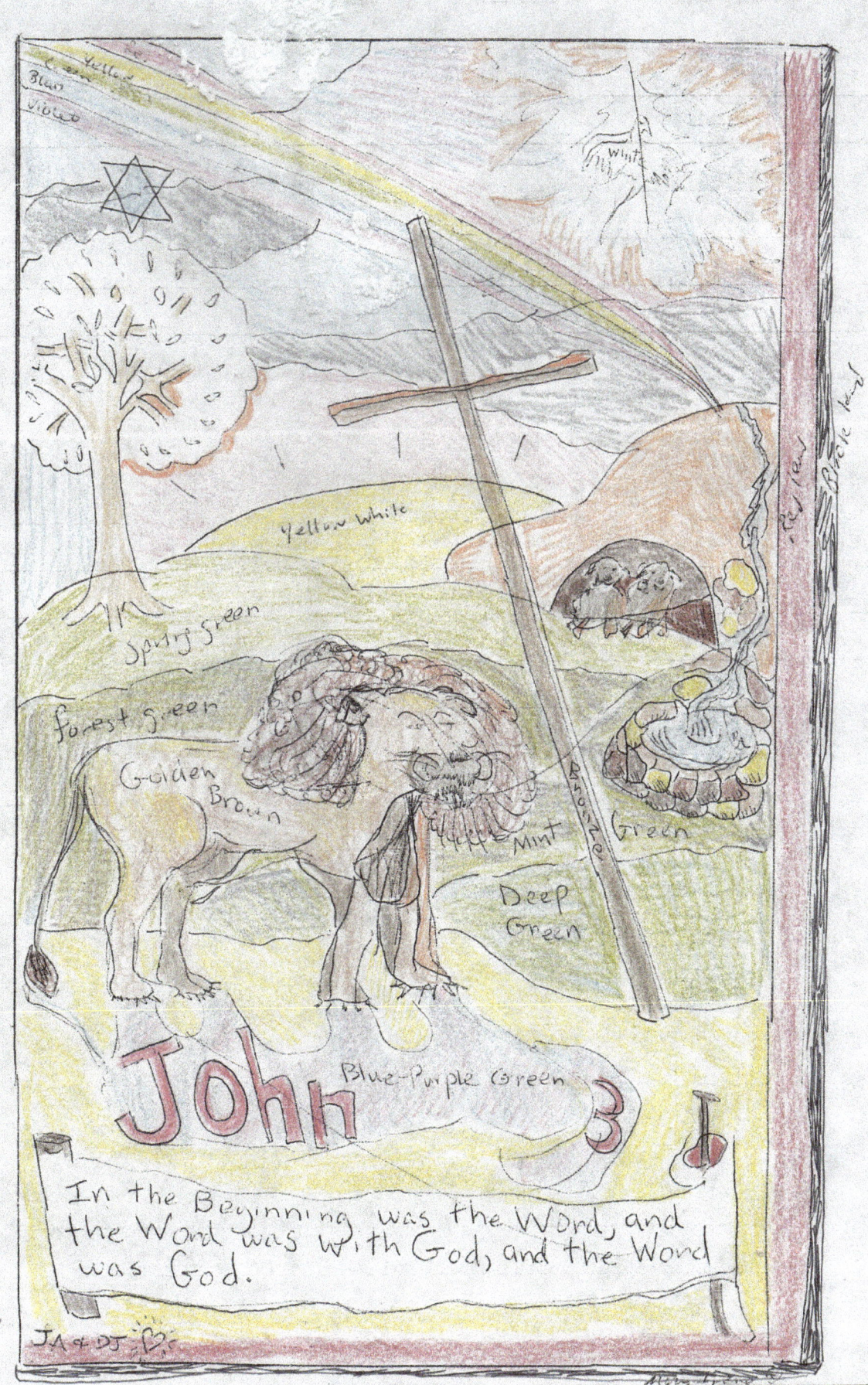

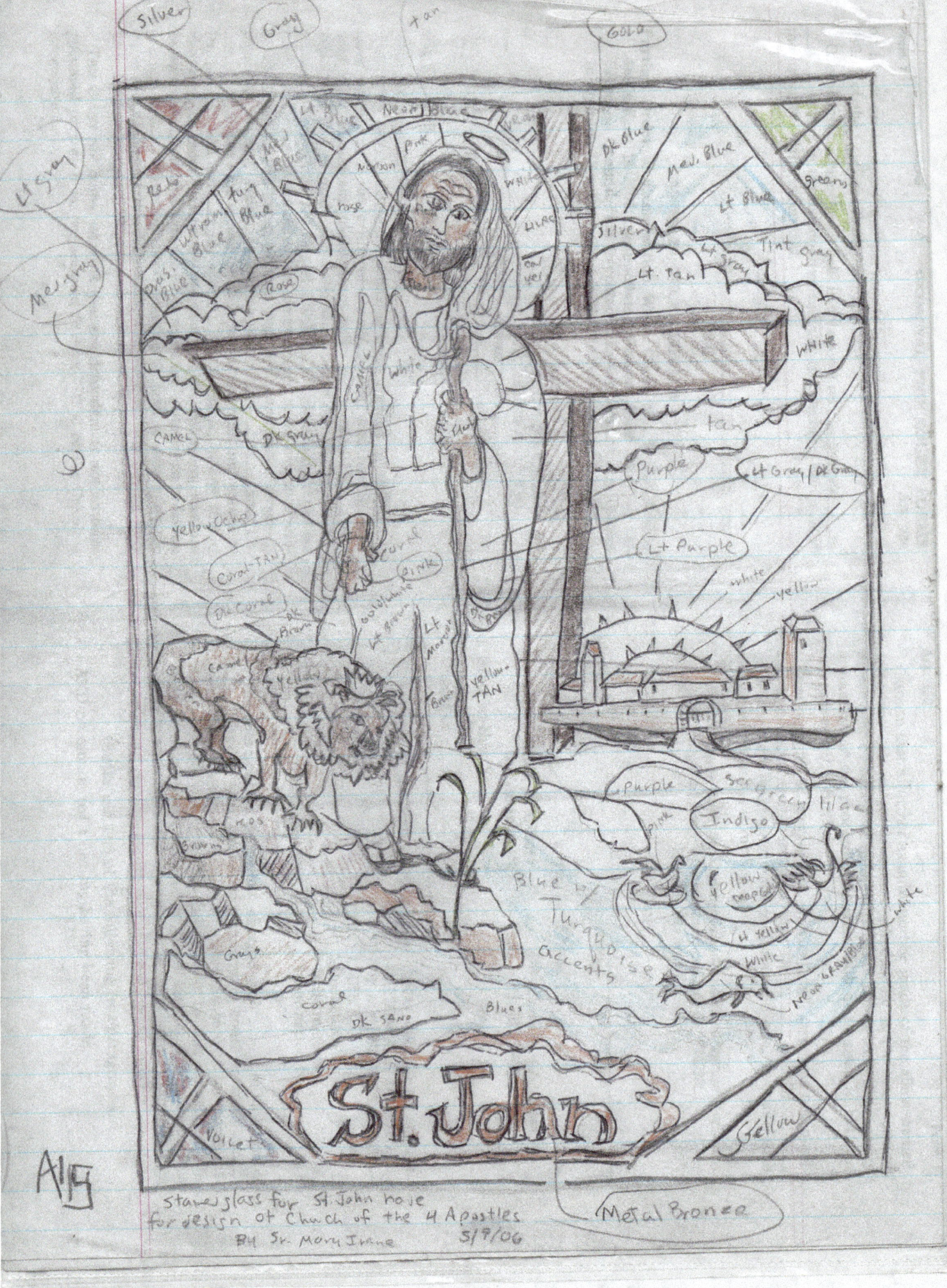

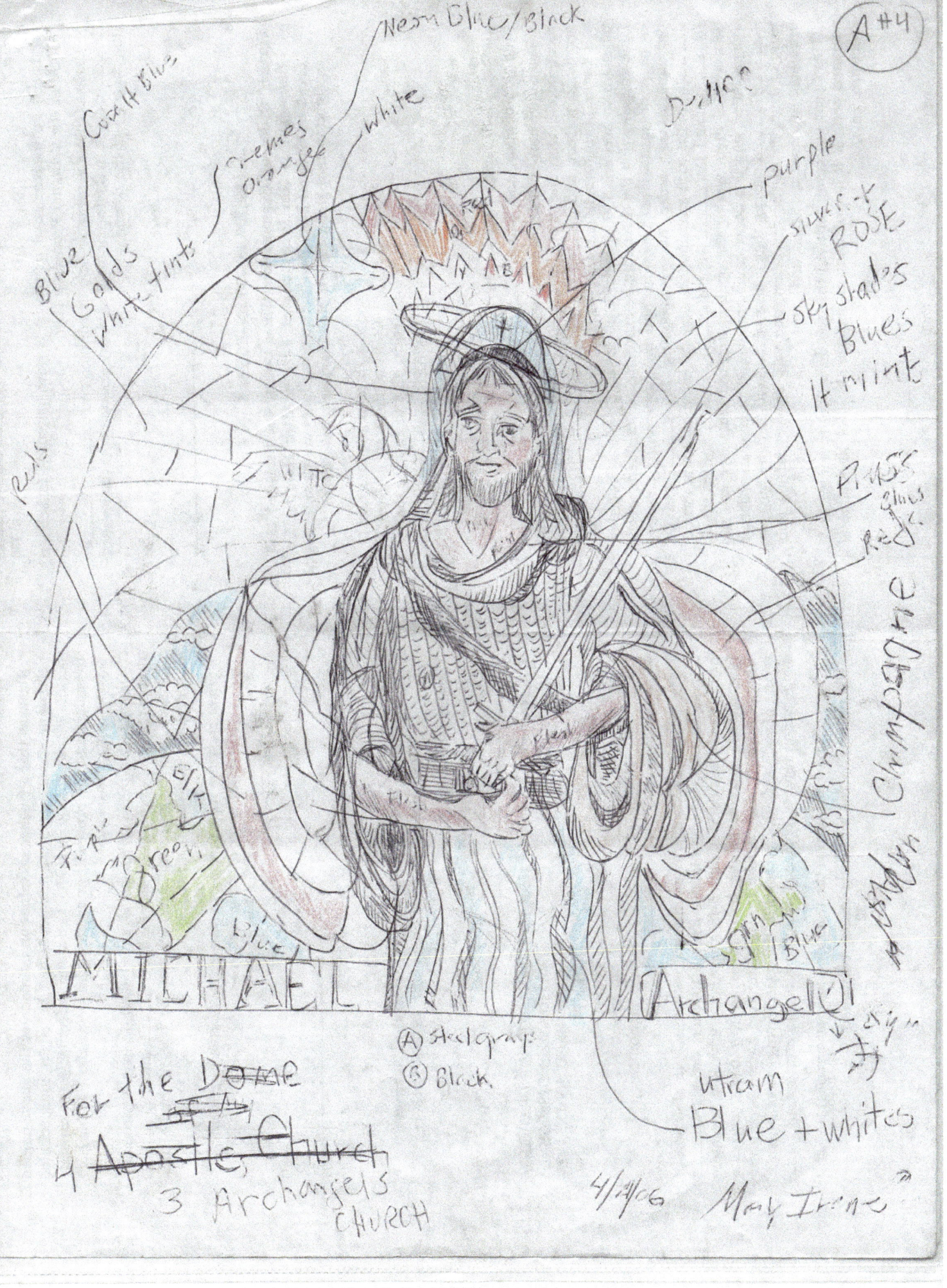

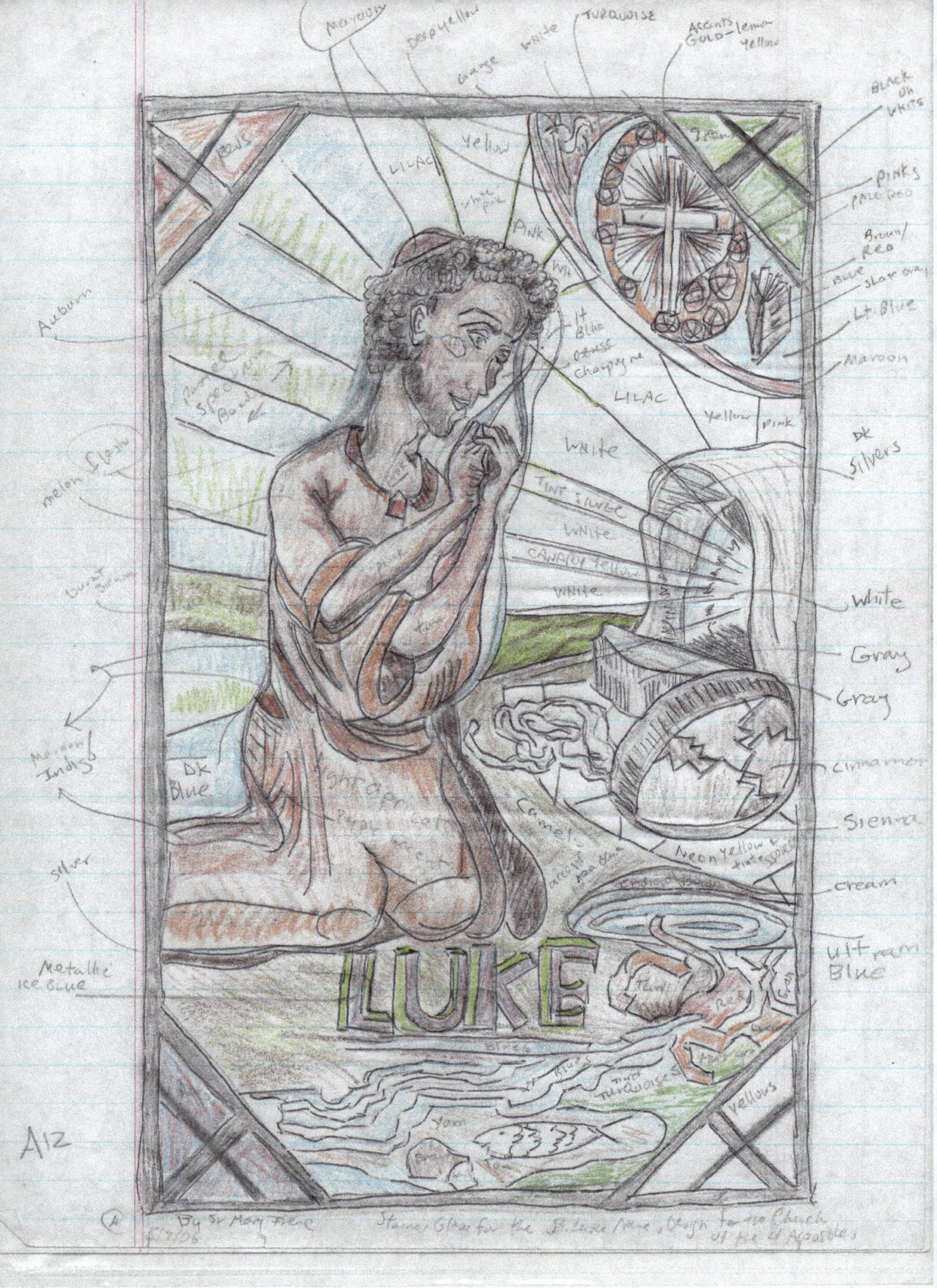

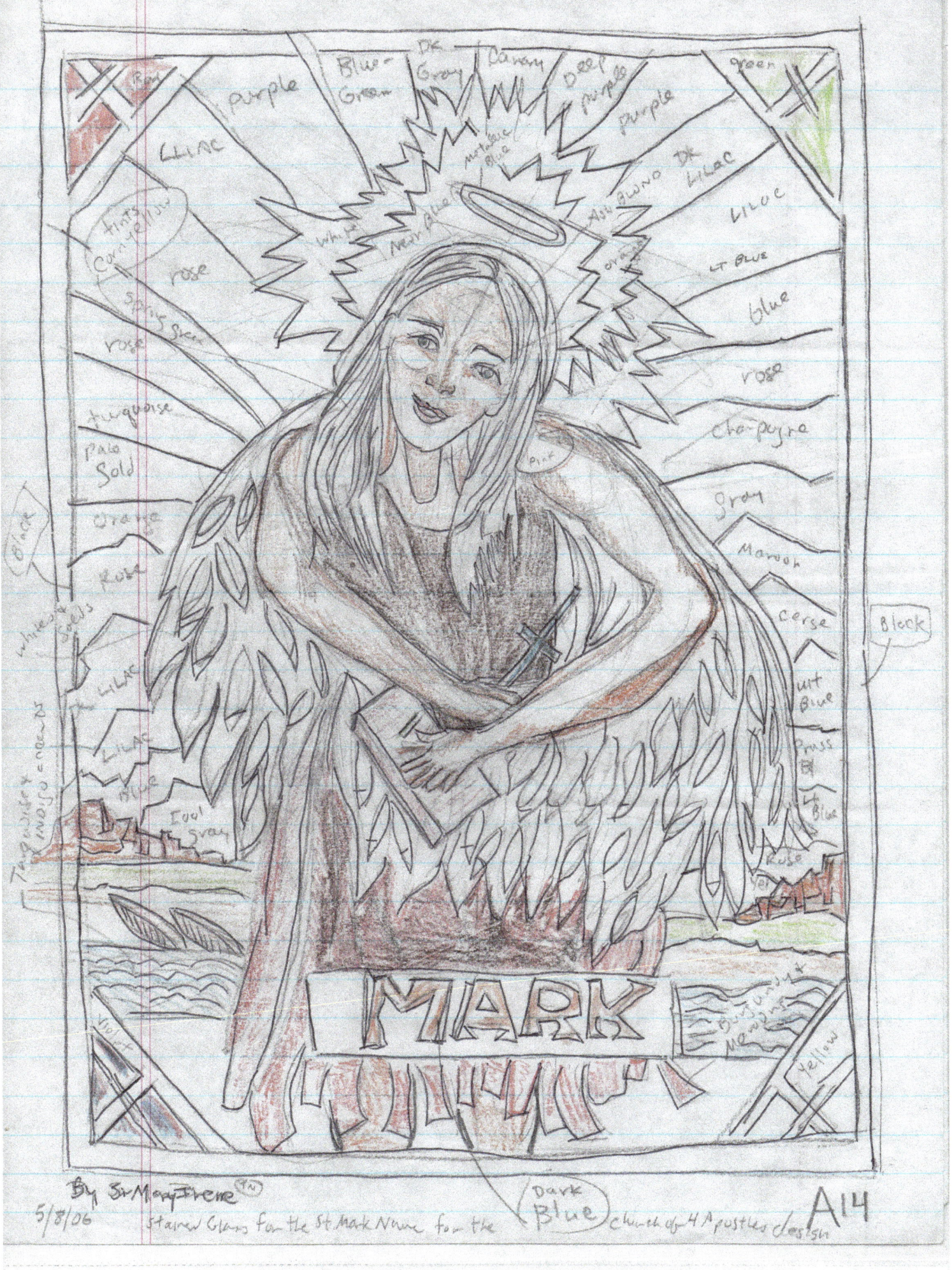

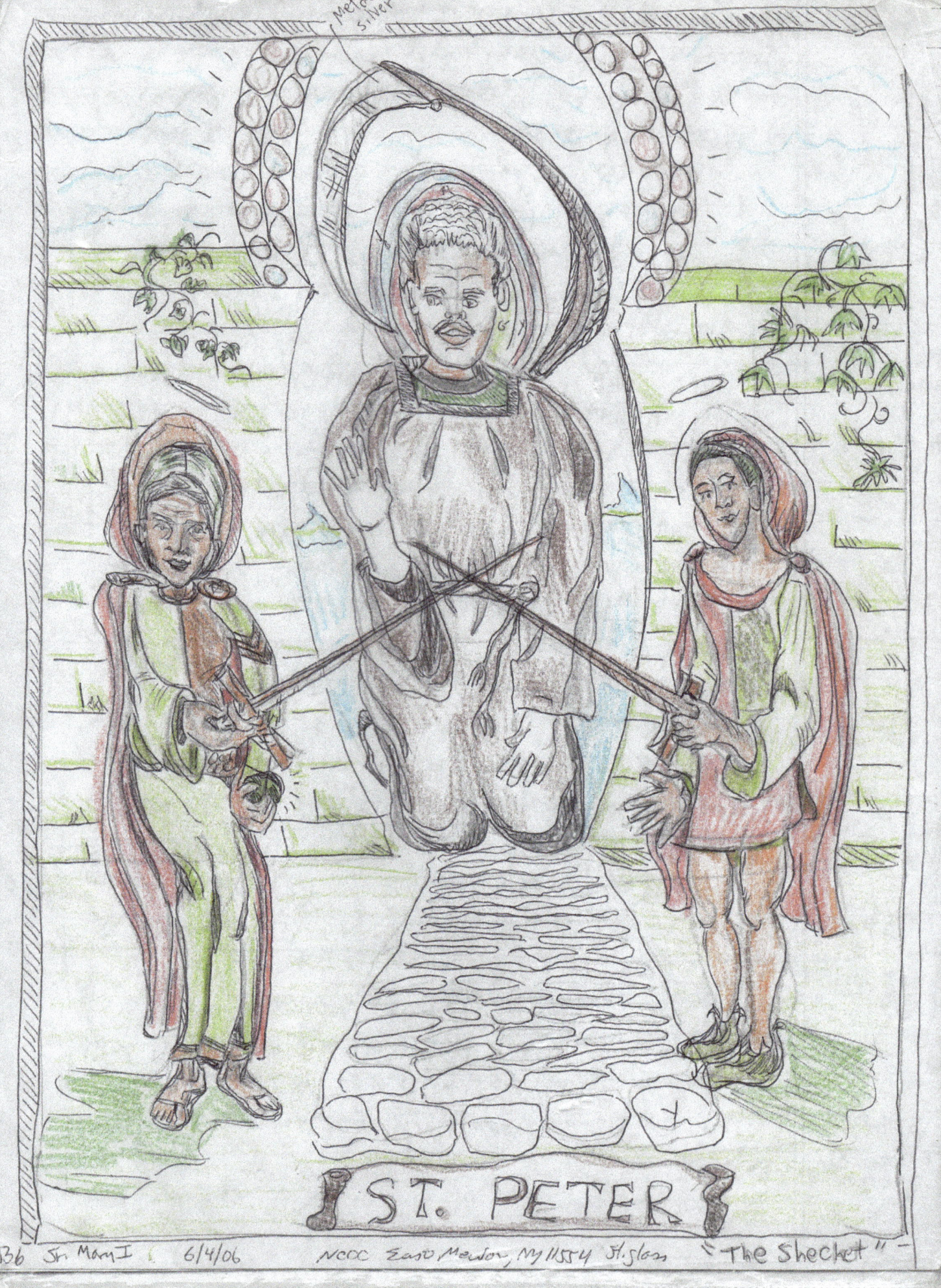

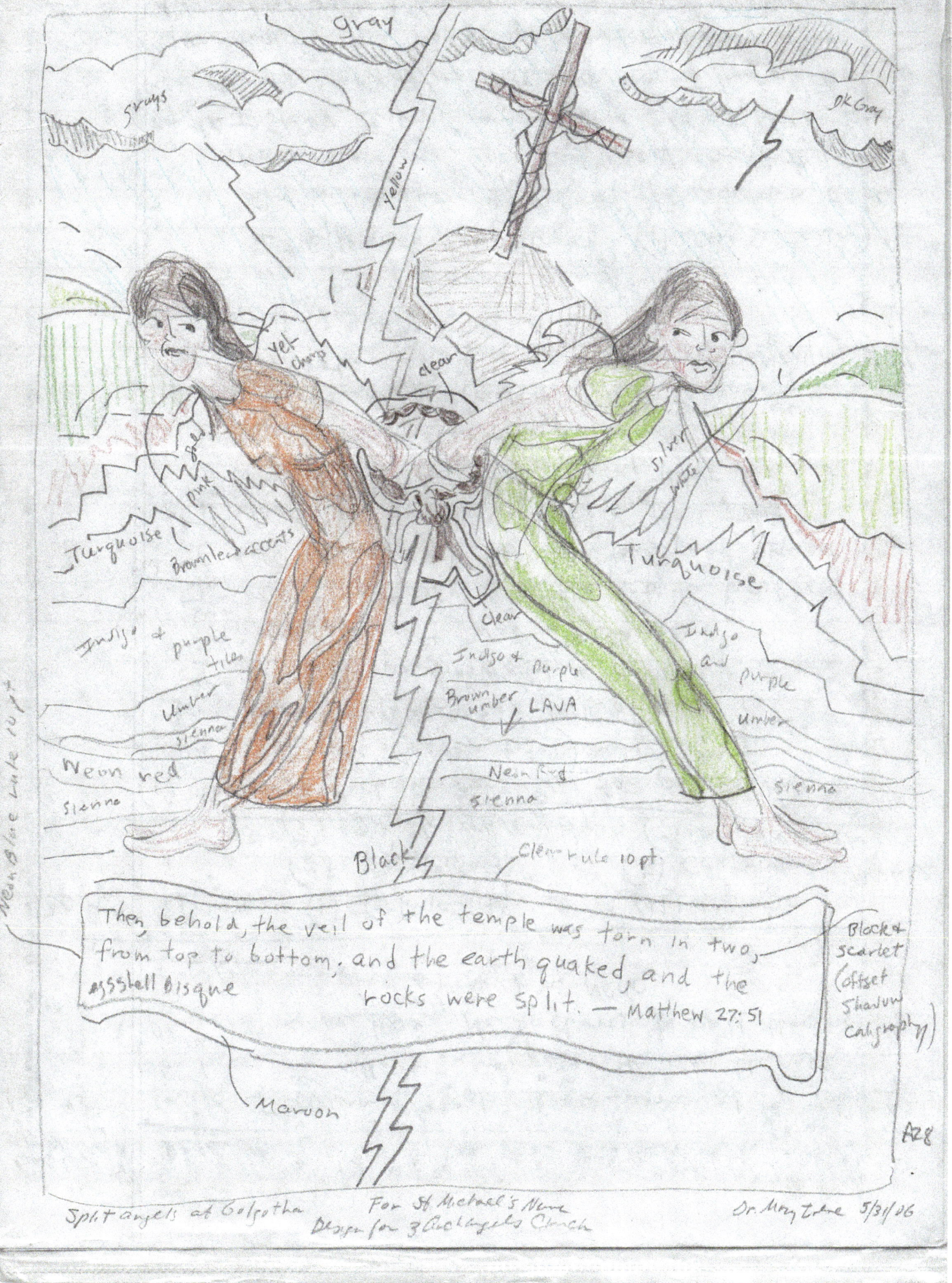

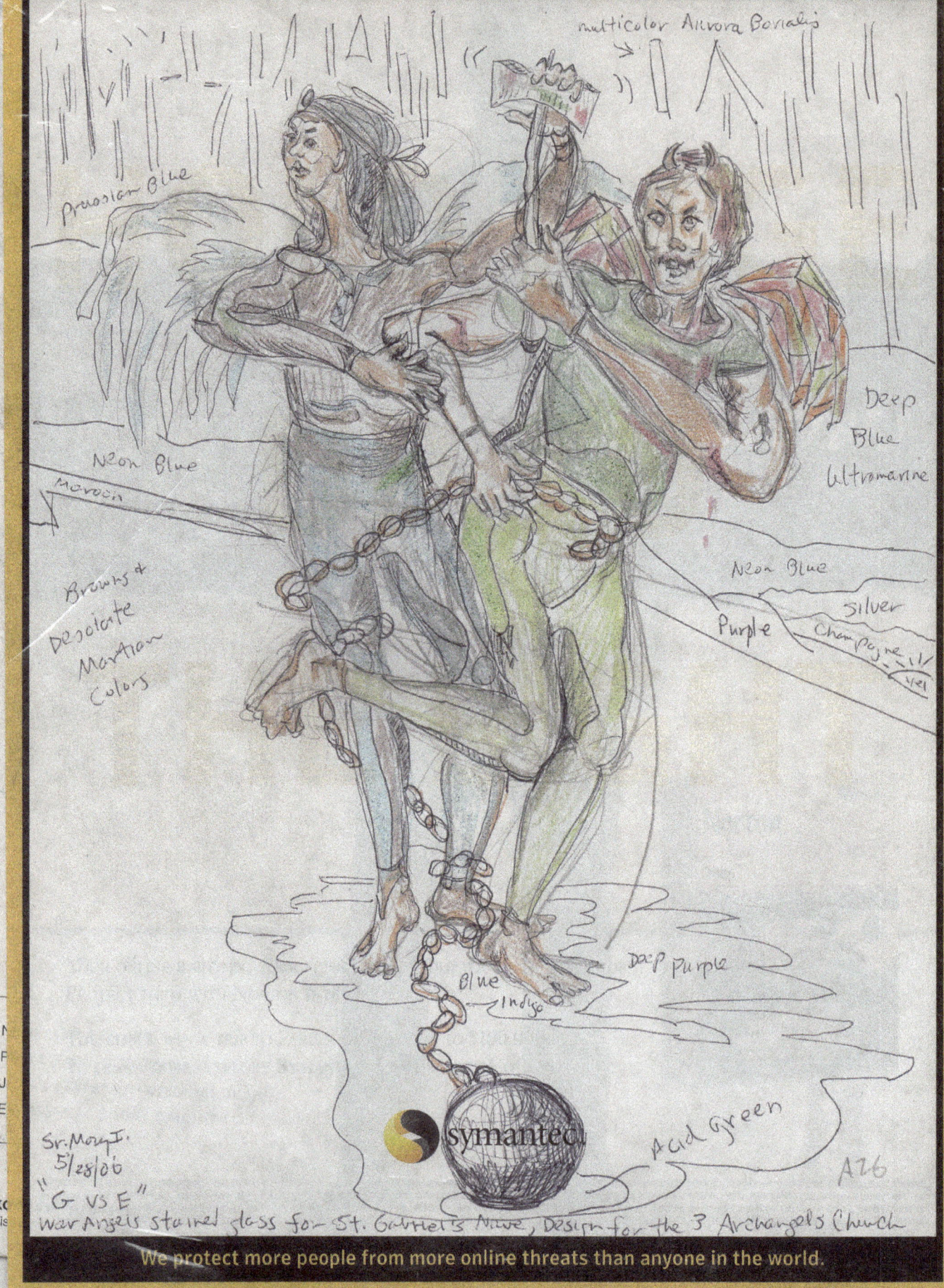

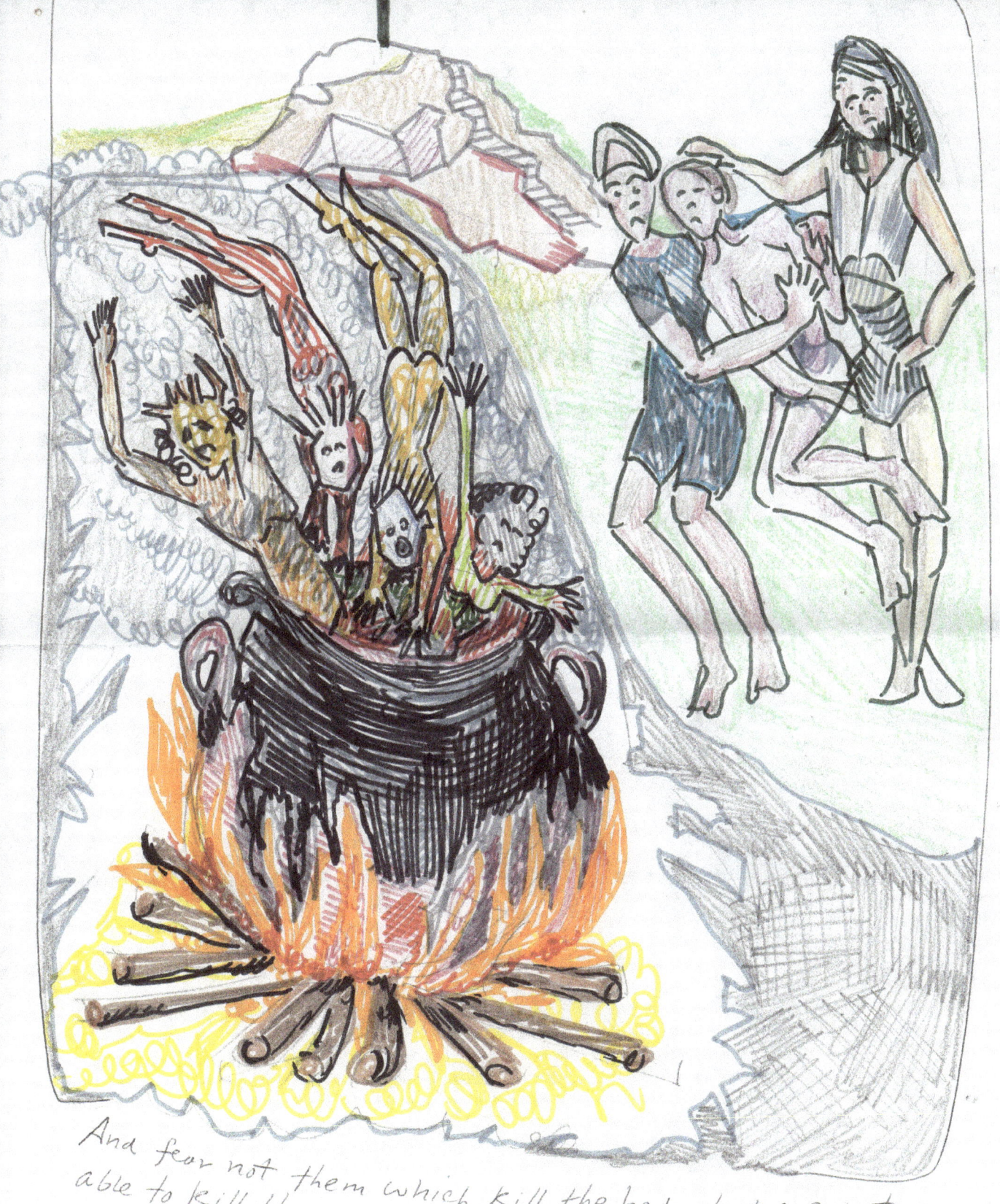

"And fear not them which kill the body, but are not able to kill the soul: but rather fear him which is able to destroy both soul and body in hell." — Matthew 10:28

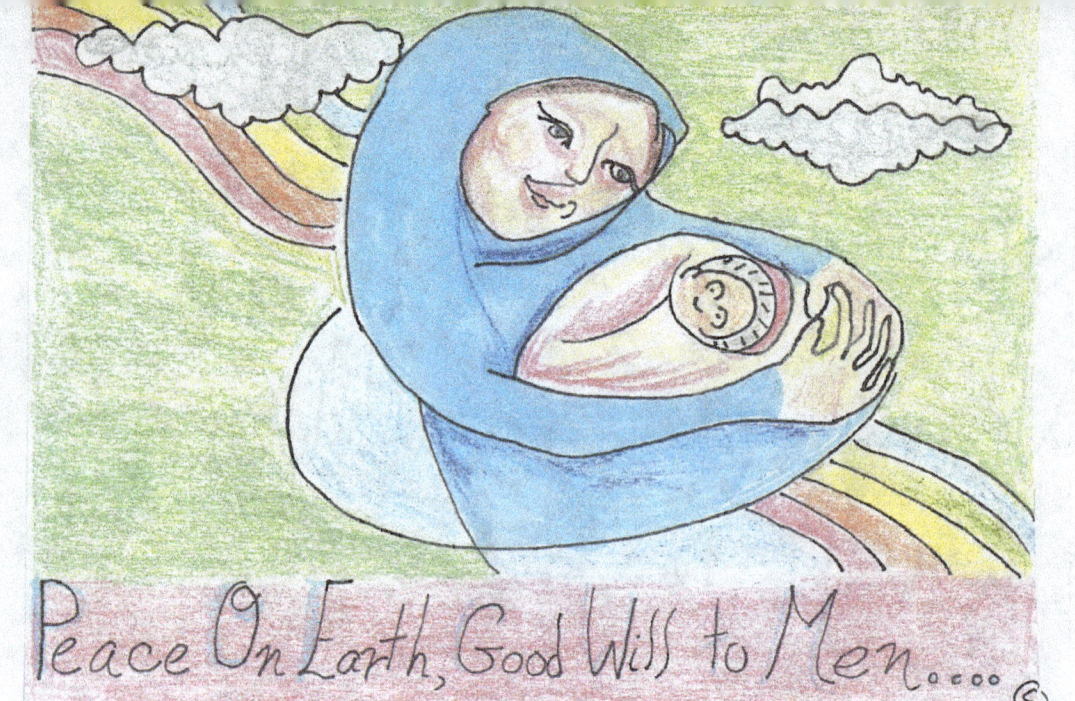

③

"CHURCH OF THE 4 APOSTLES"
AT THE CENTER OF
4 NAVES in
the shape of a cross.

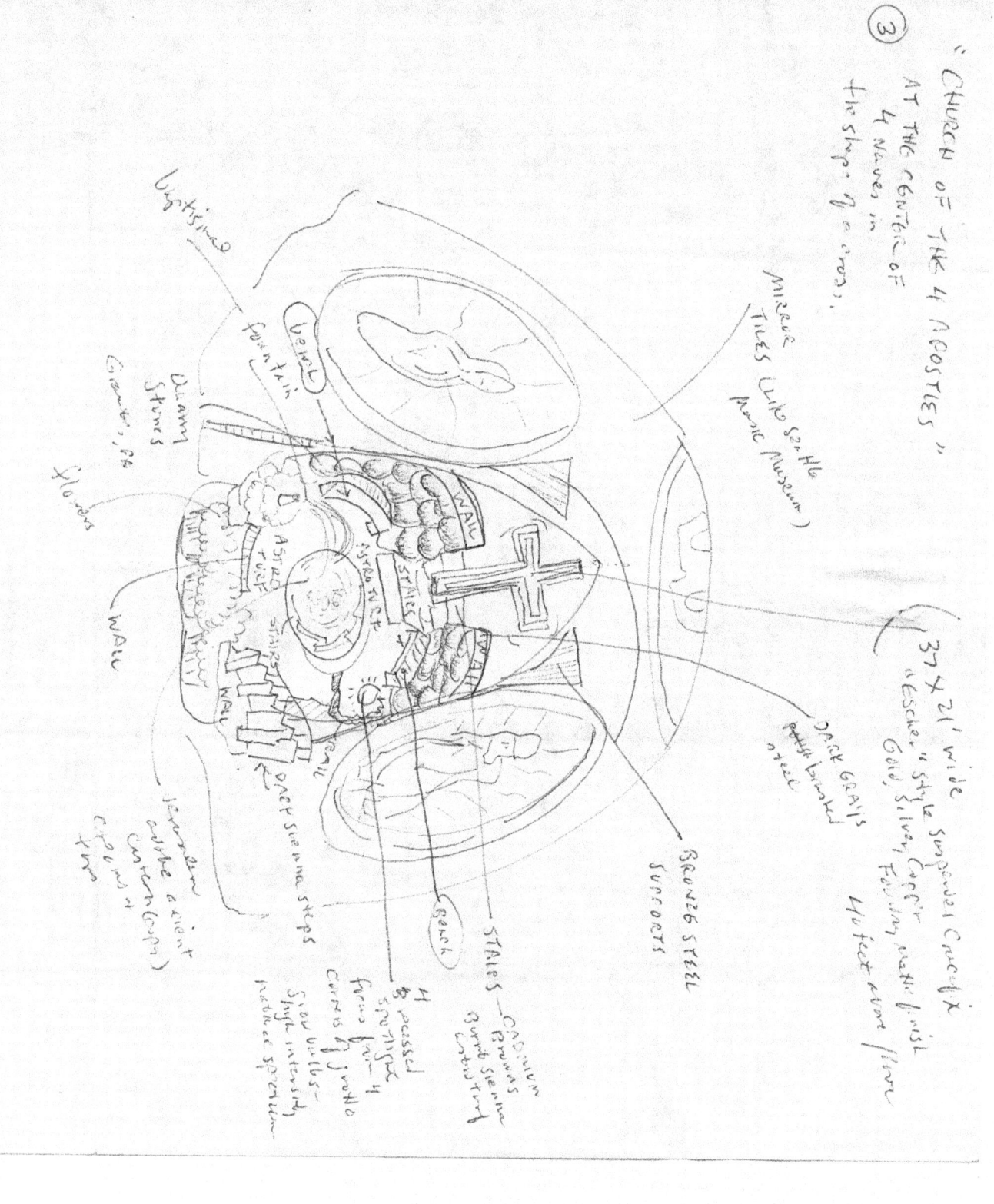

(37 × 21' wide "Escher" style suspended Crucifix
Gold, Silver, Copper, Palladium, matte finish
Water drum floor

MIRROR TILES (like Seattle Music Museum)

DARK GRAYS
Polish bonded
steel

BRONZE STEEL SUPPORTS

STALLS — CADMIUM
Browns
Burnt Sienna
Existing

Bench

4 recessed
spotlights
from fountain
curves & grotto
Single intensity
natural spectrum

DARK Sienna steps

travertine ancient
aisle & vent
catch (cups)

Cage end ↓
pan

WALL

flowers

Granite, GA
Quarry
Stones

Bowl
fountain

lightsince

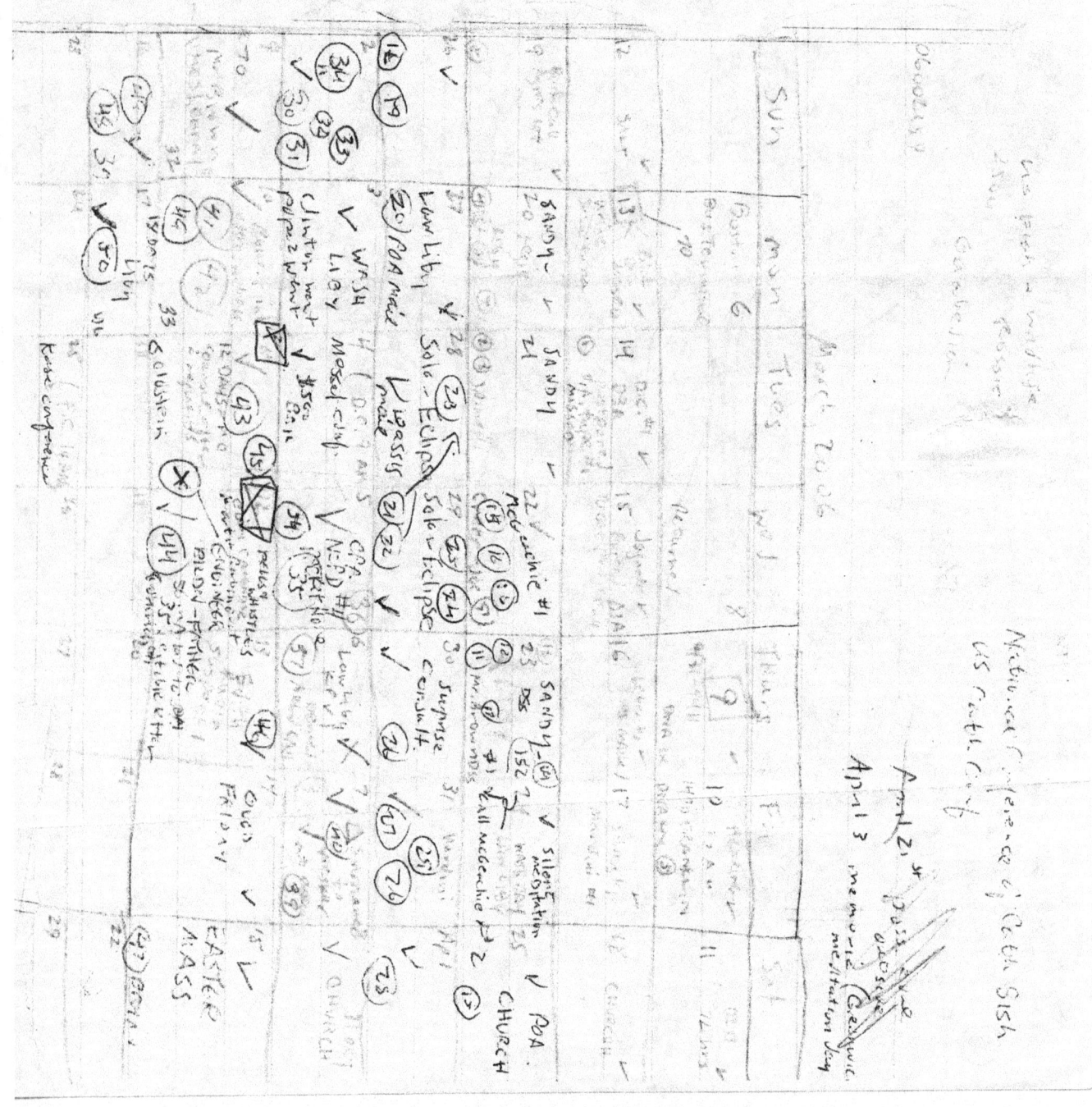

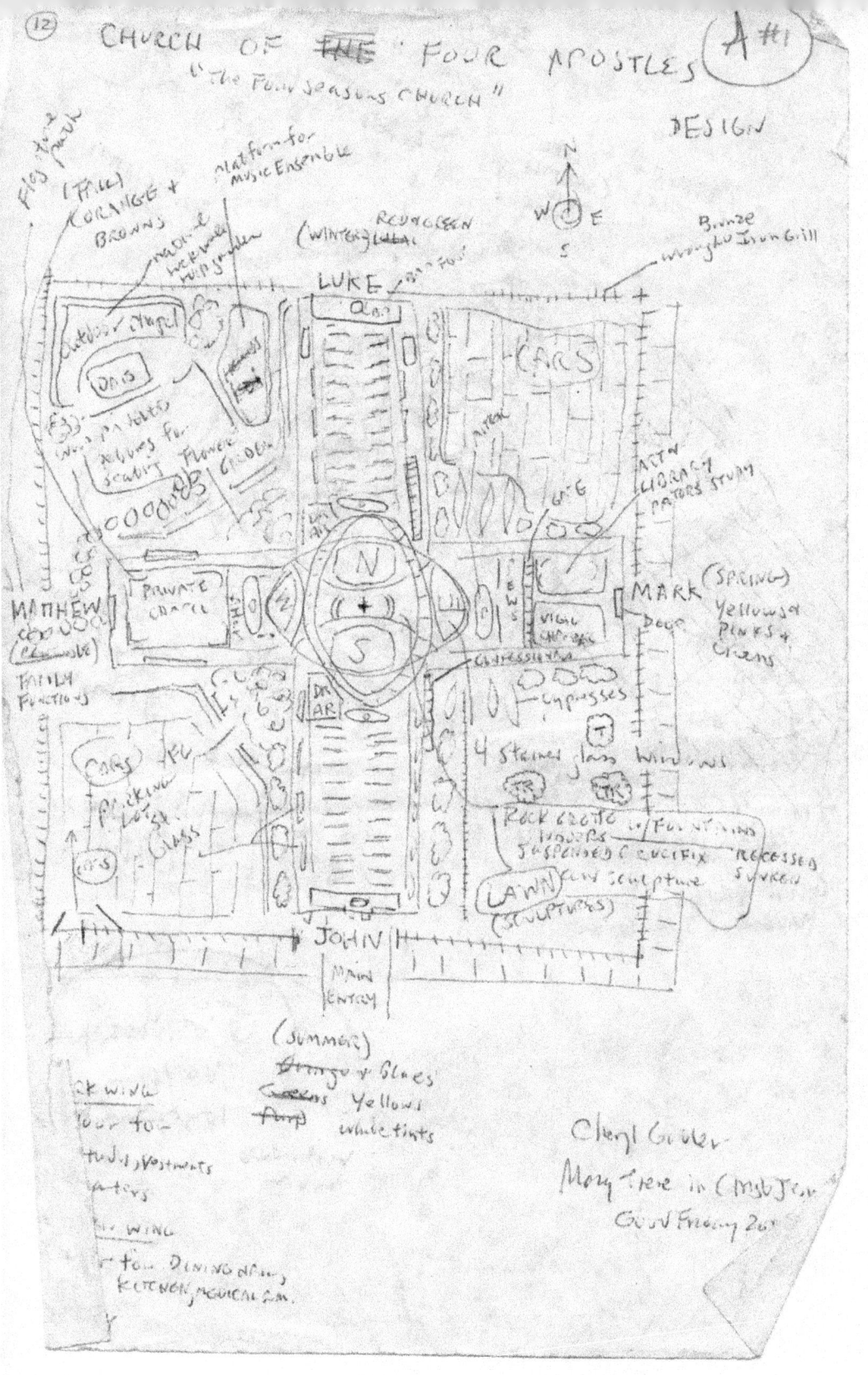

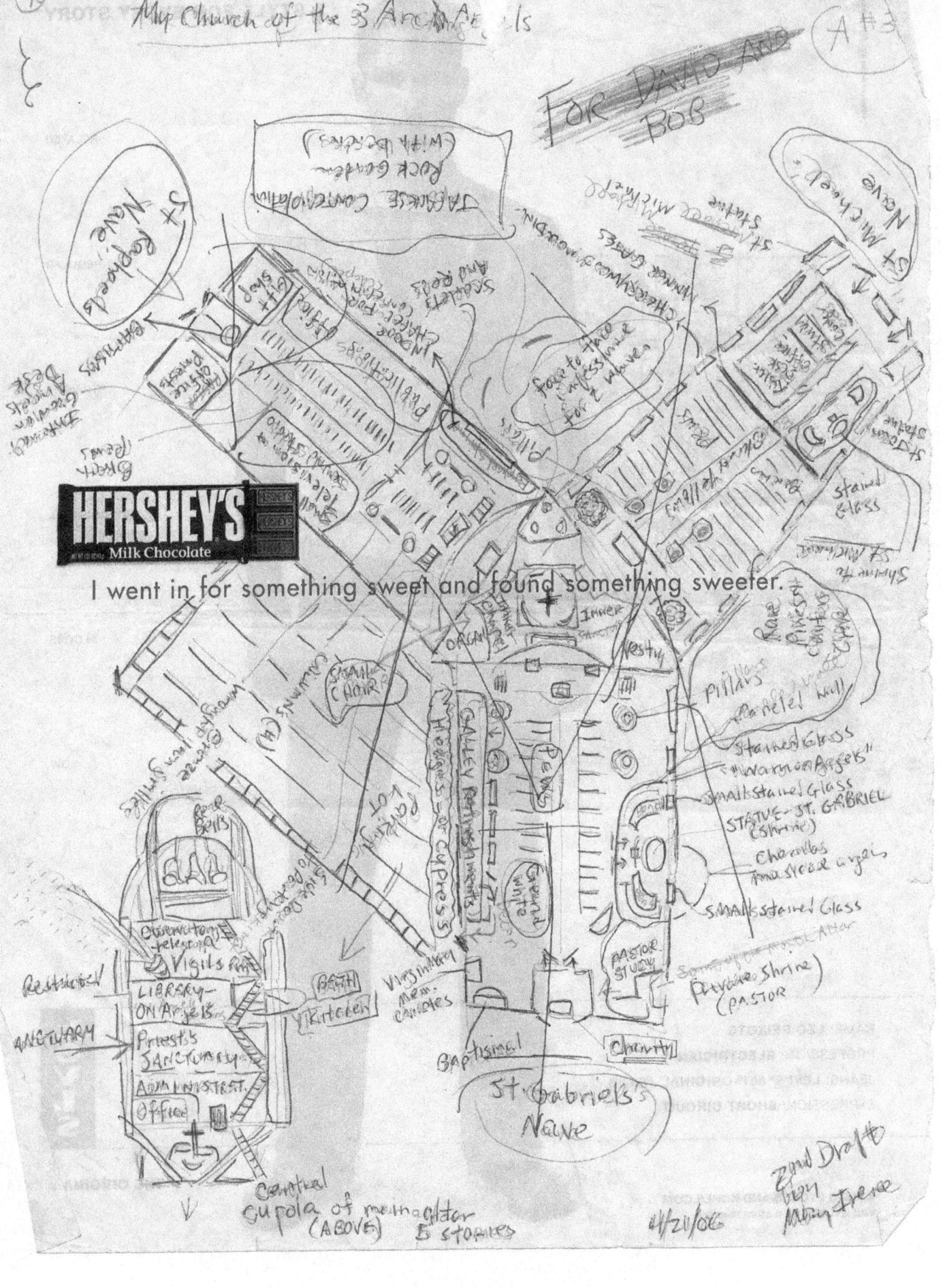

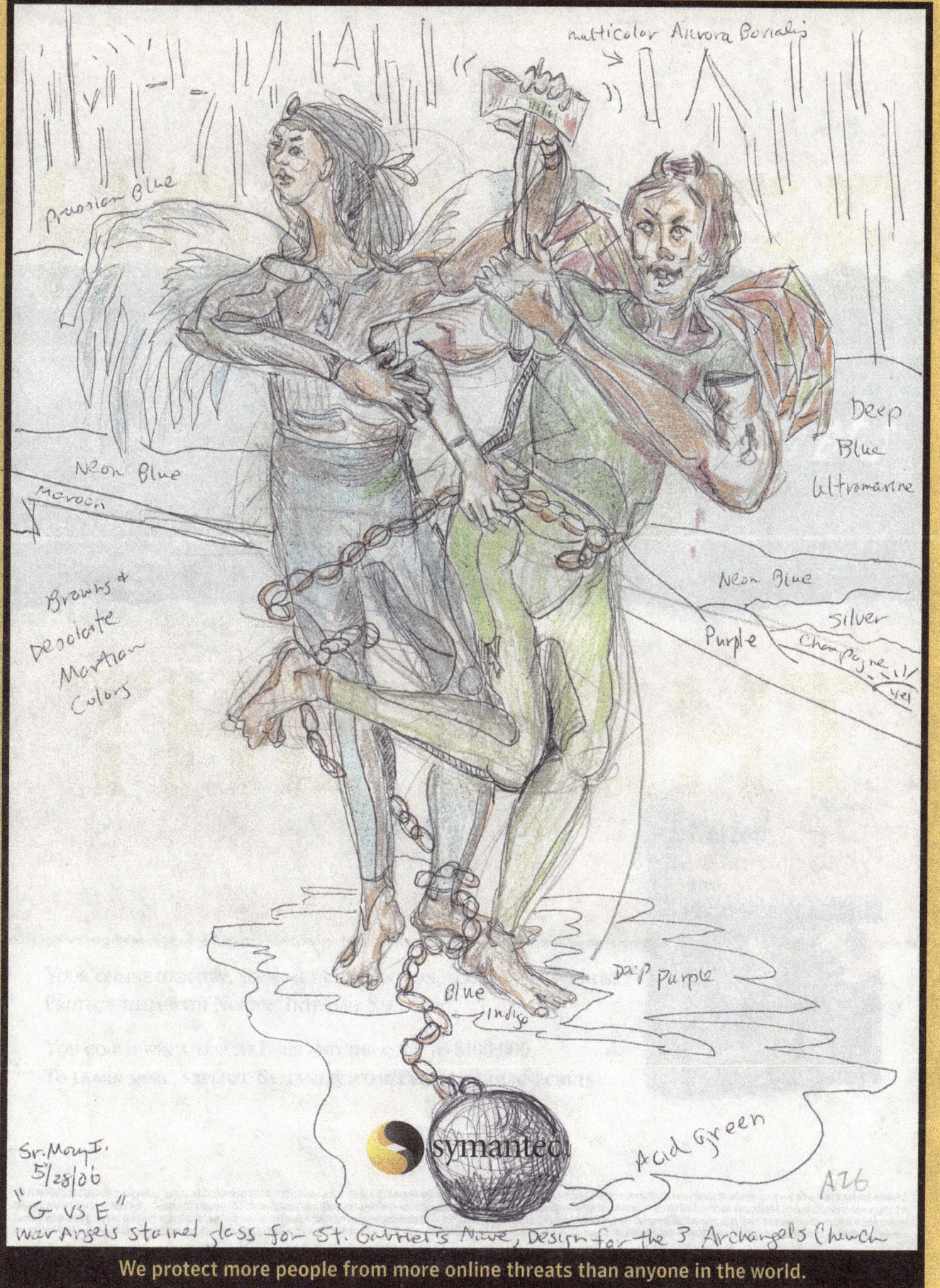

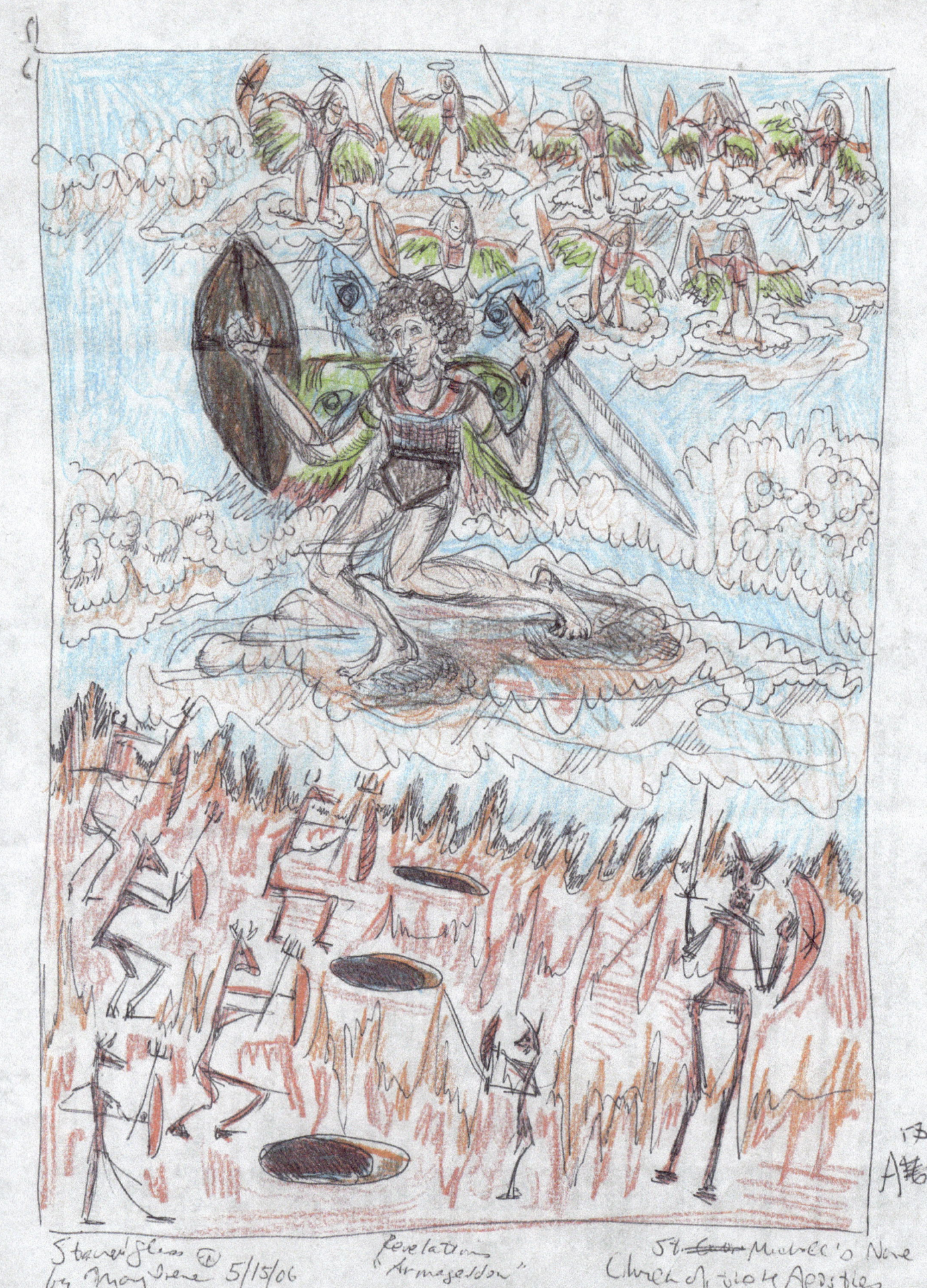

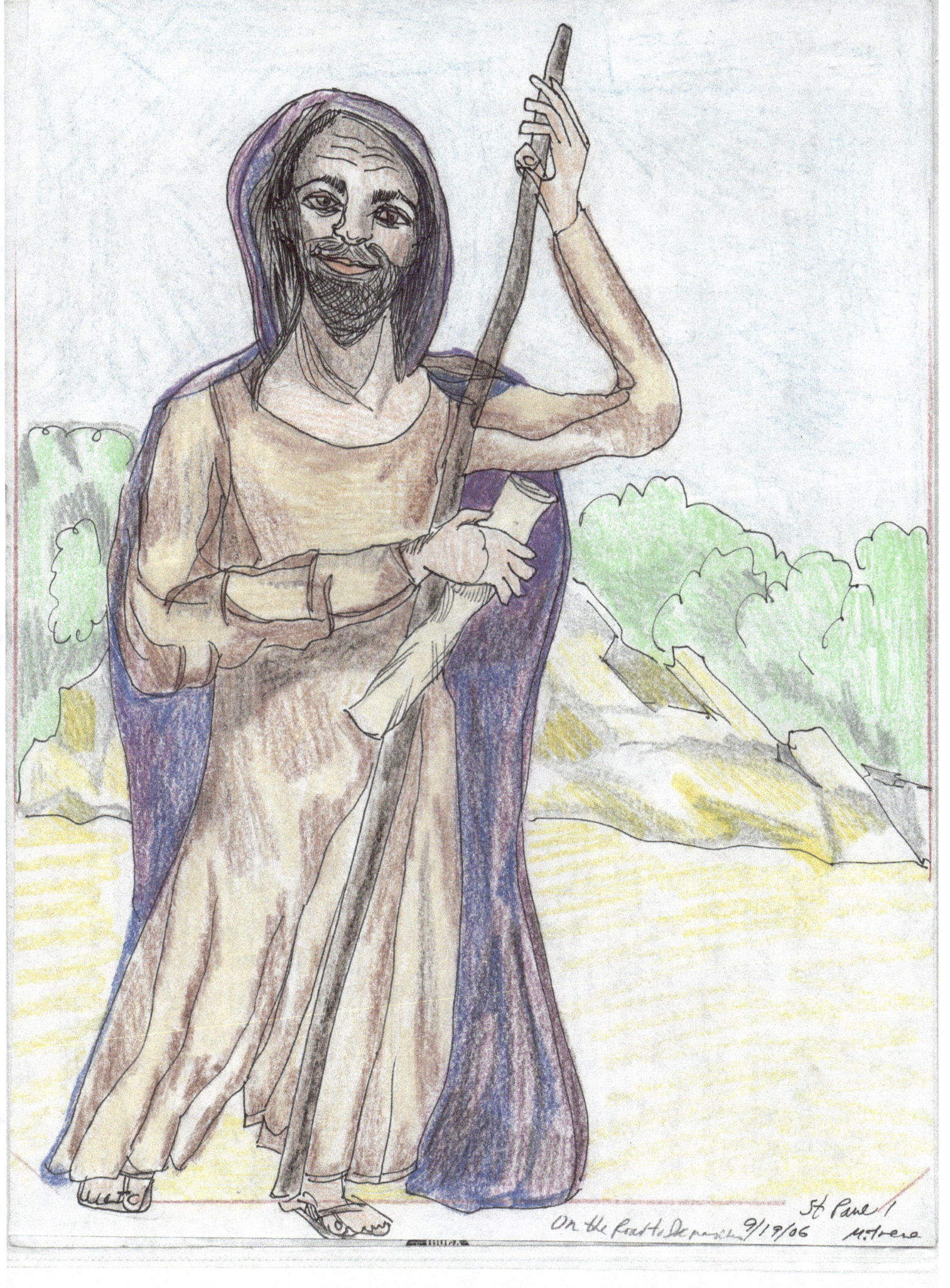
On the Road to Damascus 9/19/06 St Paul
M. Irene

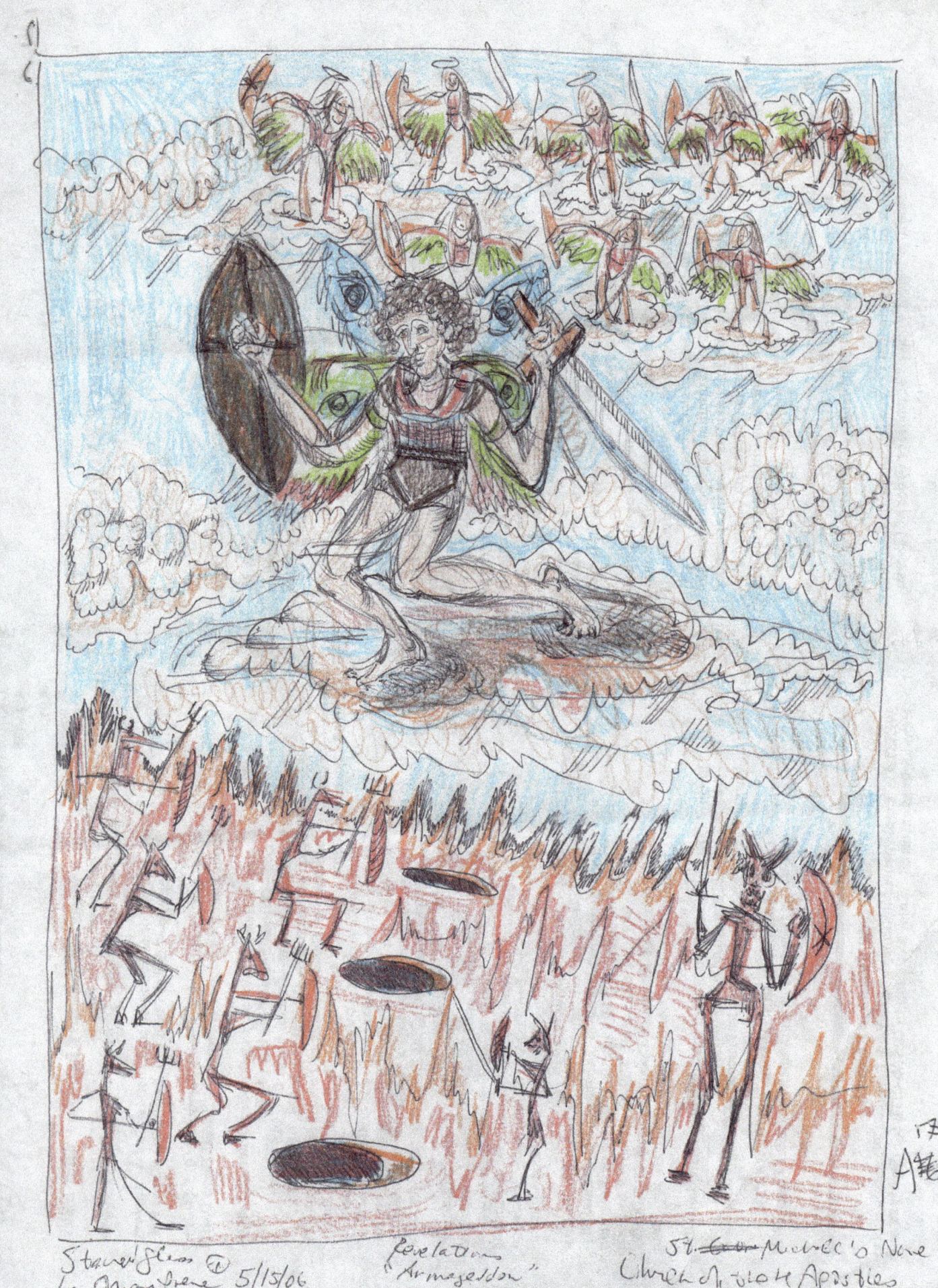

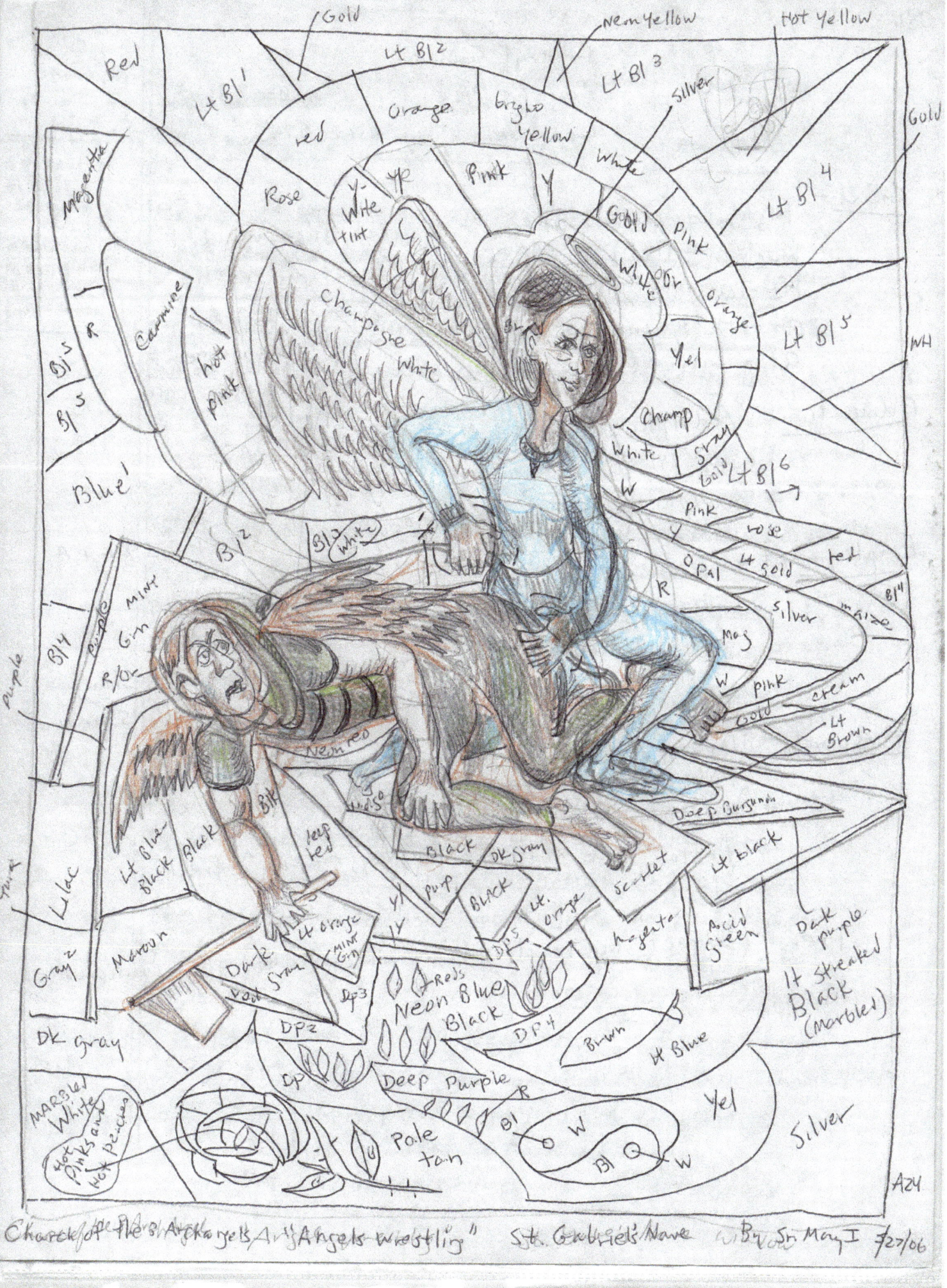

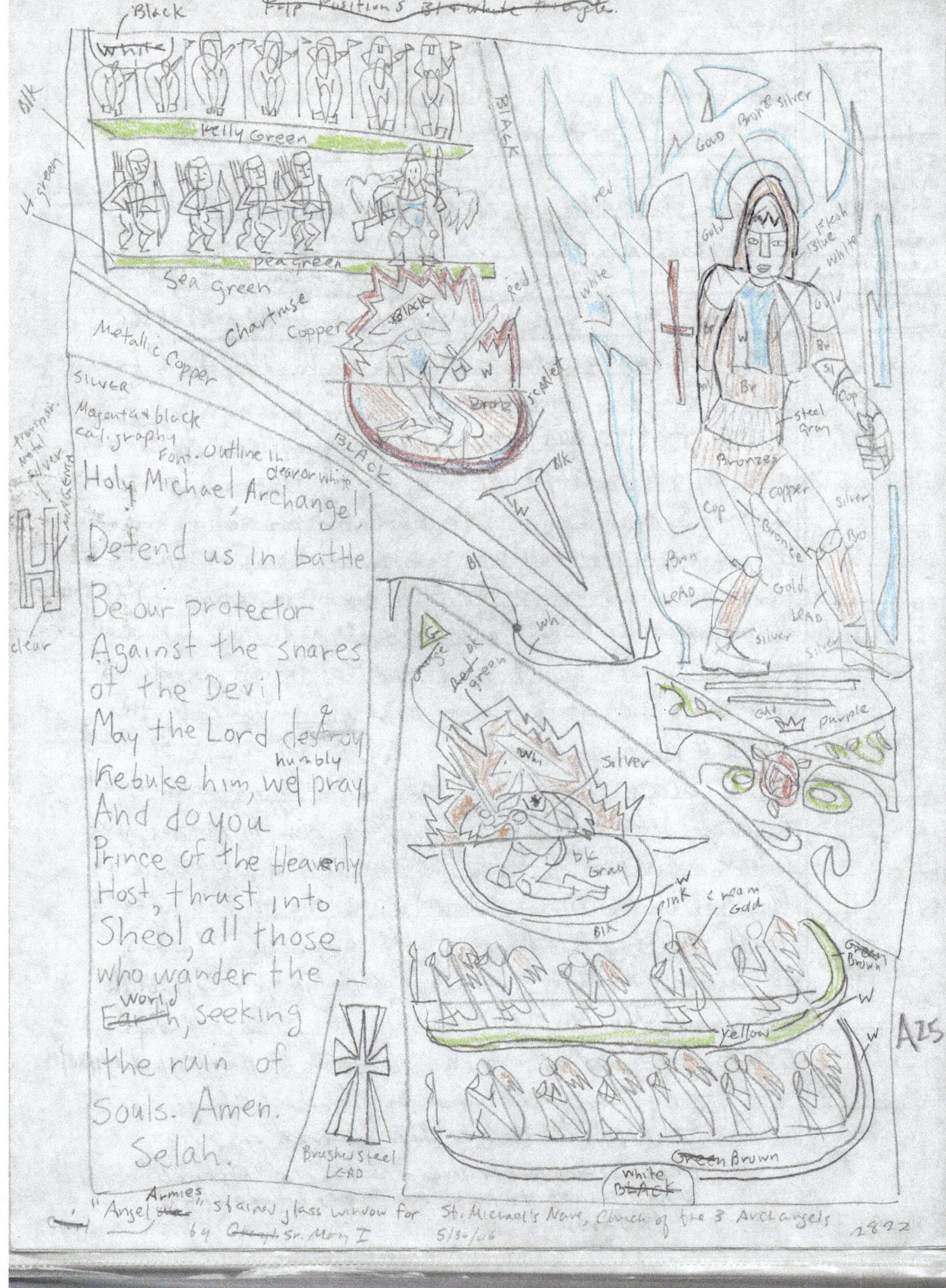

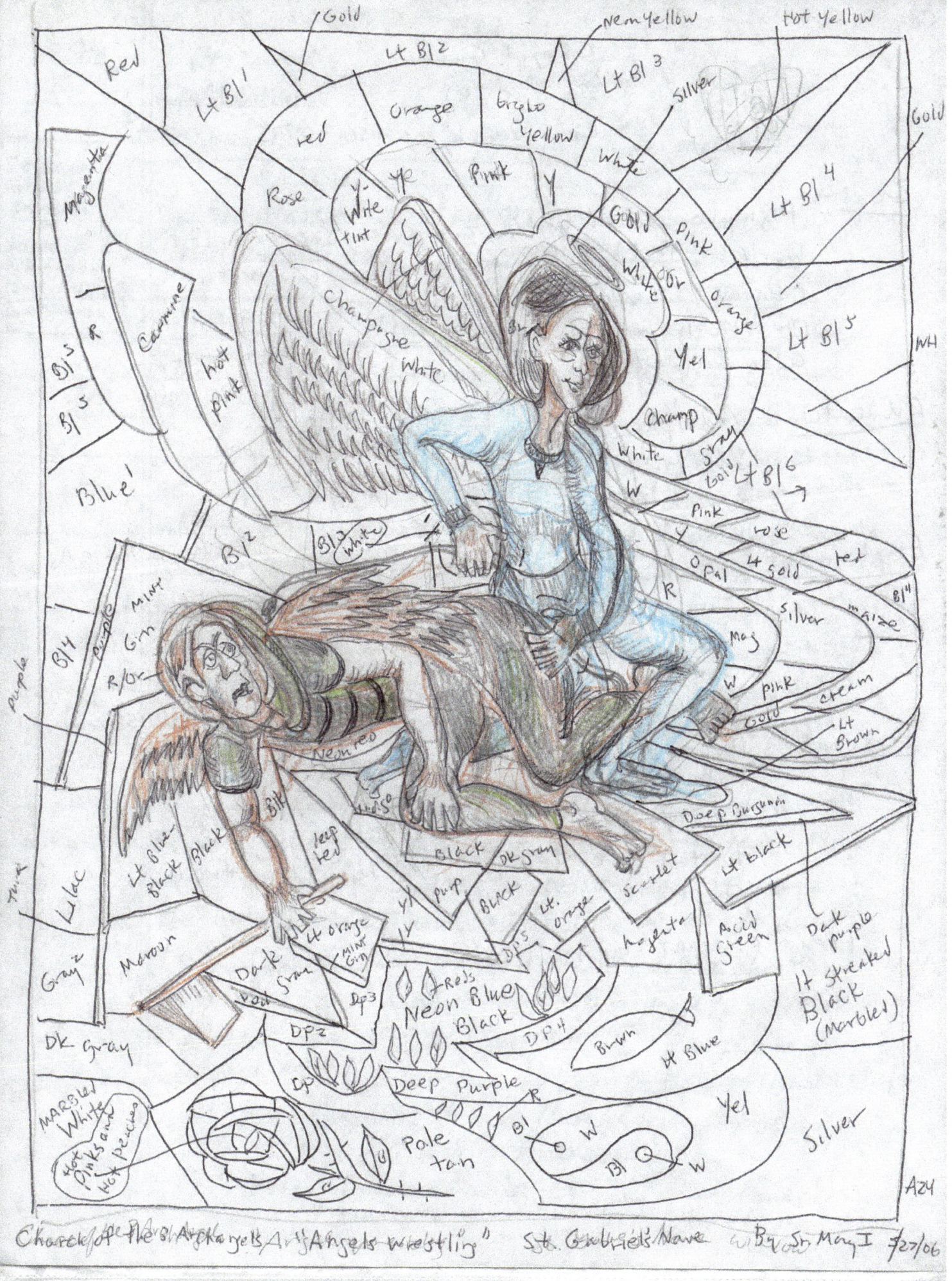

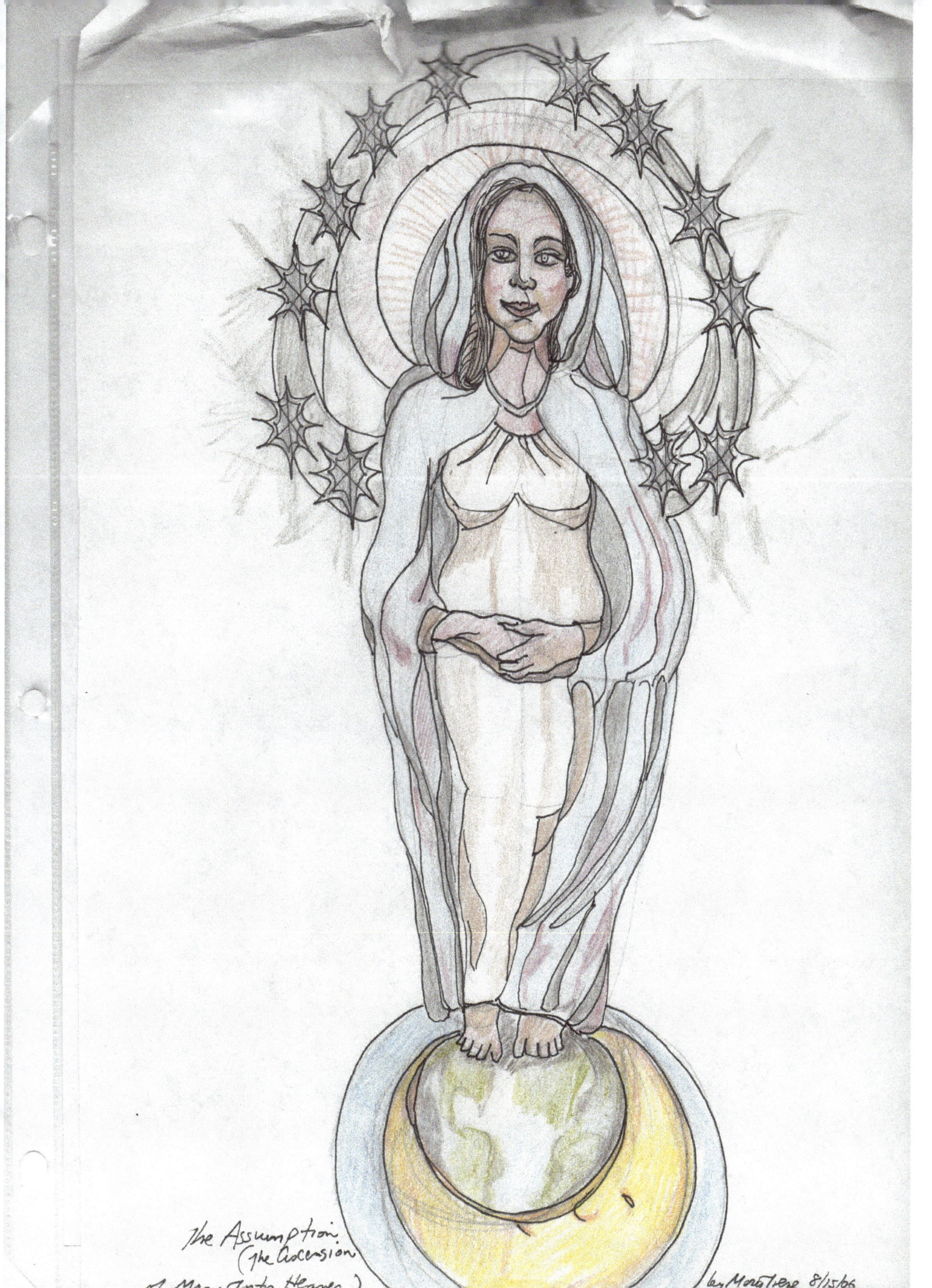

The Assumption
(The Ascension
of Mary into Heaven)

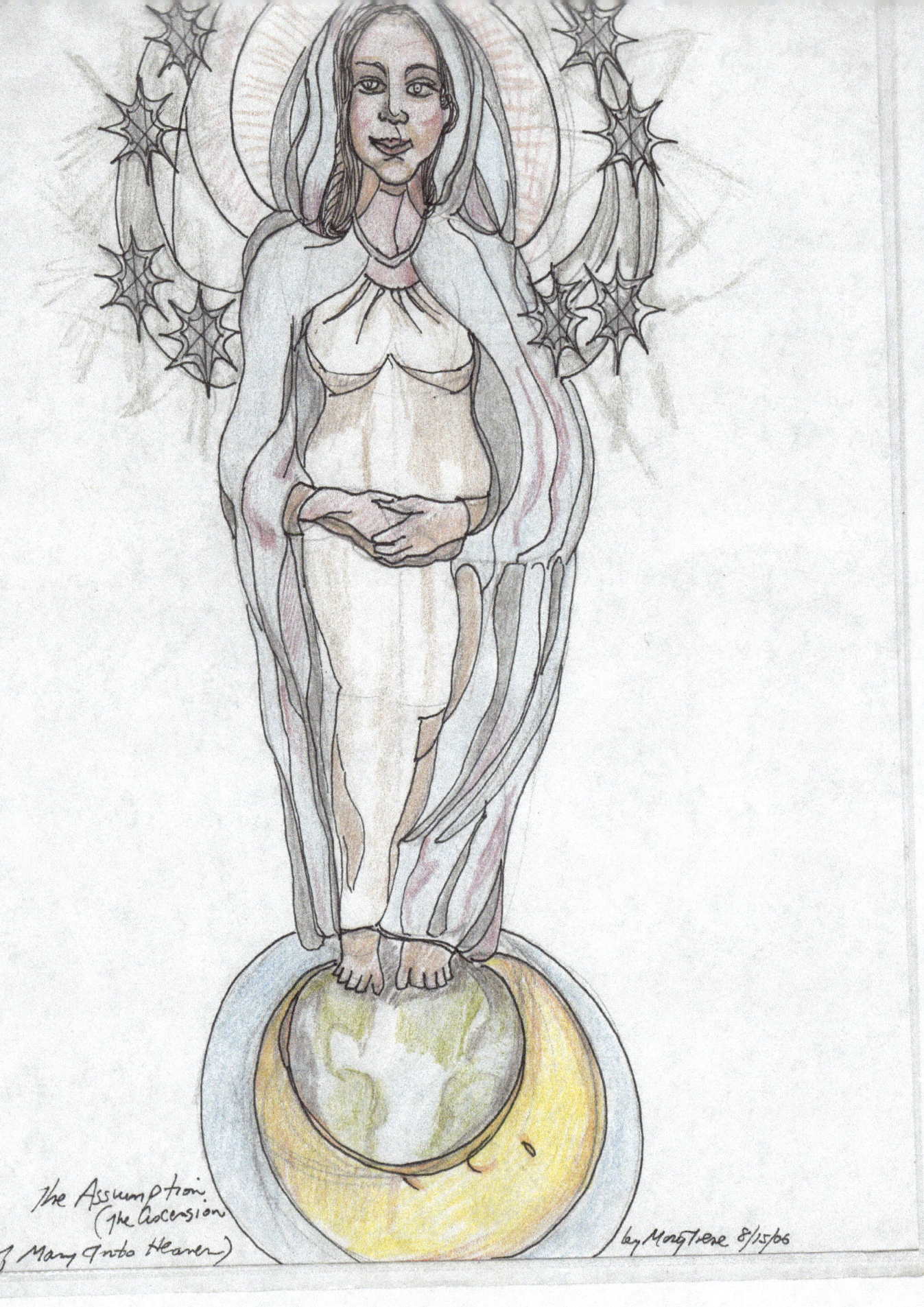

The Assumption (The Ascension of Mary Into Heaven) by MaryIrene 8/15/06

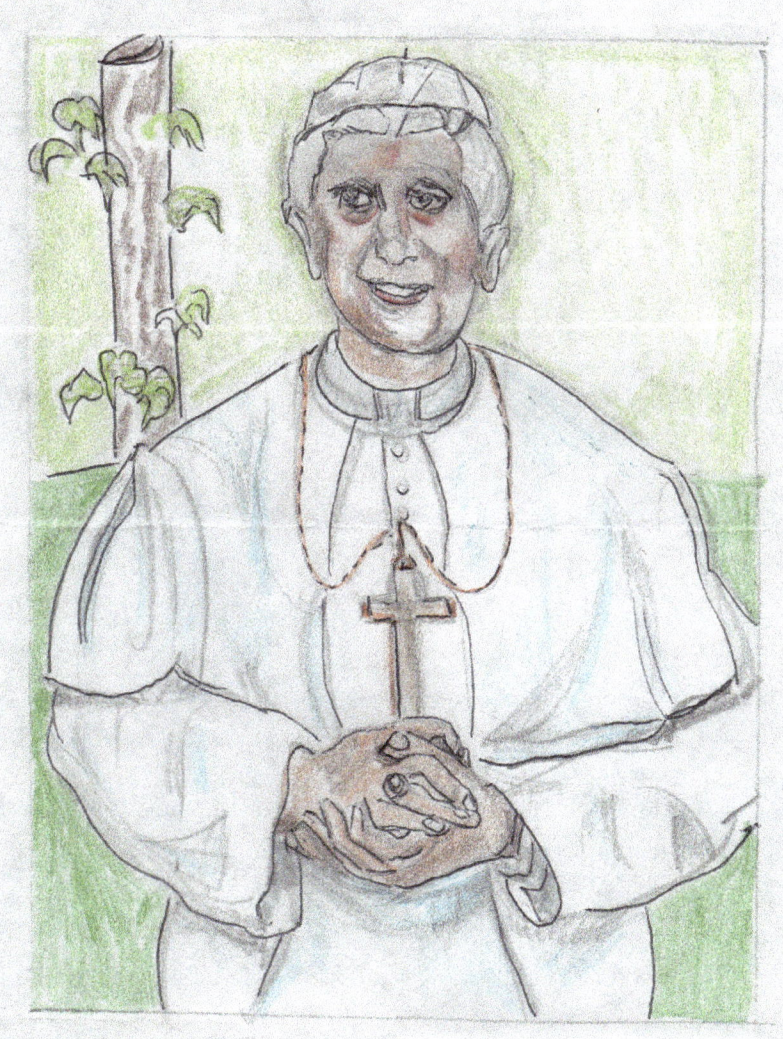

His Holiness

Pope Benedict XVI

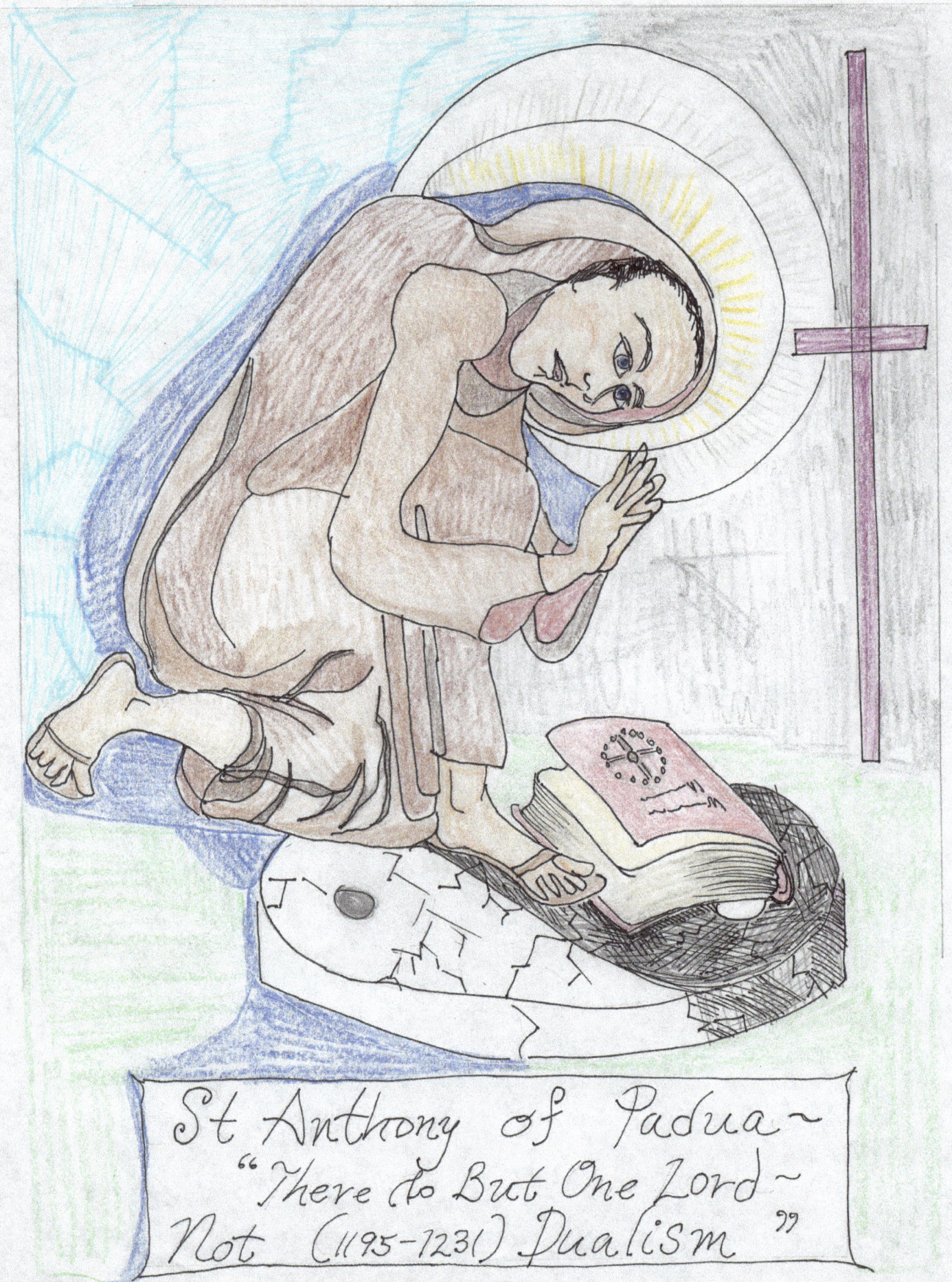

Seek The Companionship of the Holy...

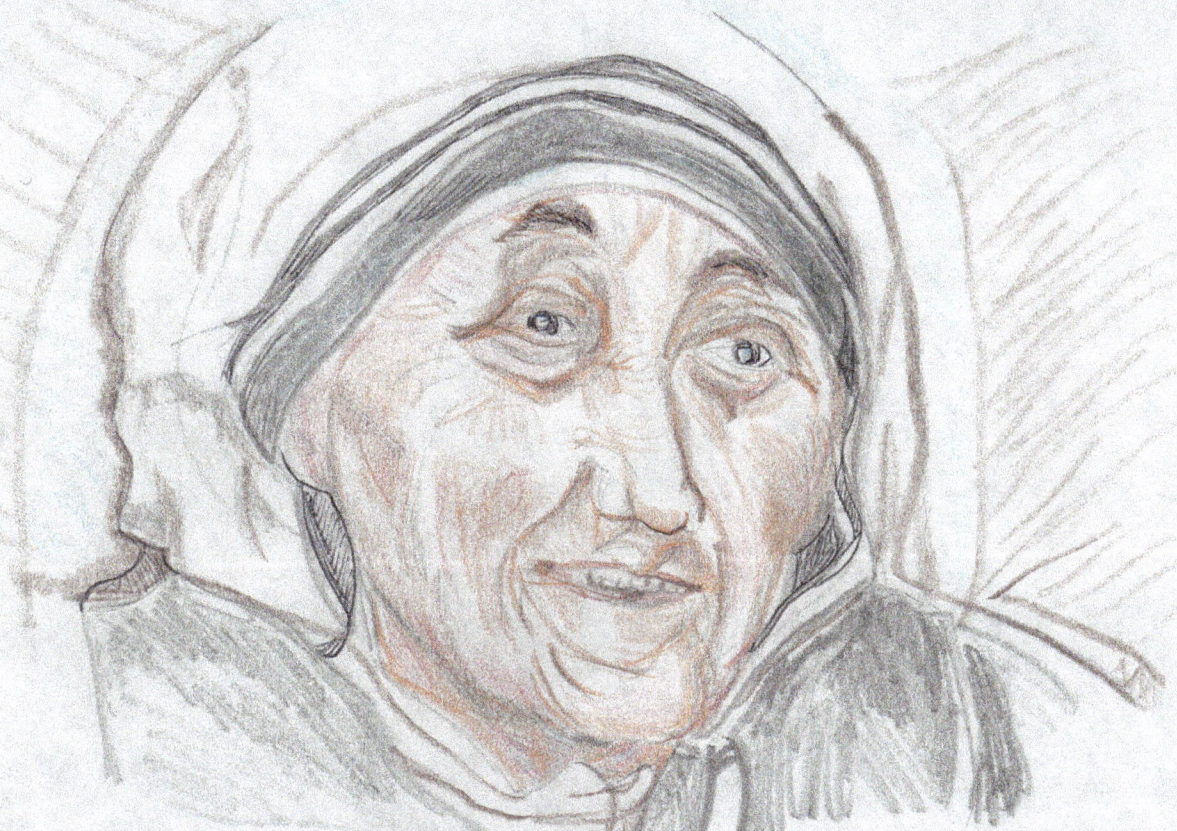

Did God welcome you into His Kingdom, "Mother T"
 Or grant you an extension on Earth?
If I were your baby, and you, my Mother,
 I'd have been much sweeter,
 a much better daughter
As would all women with you!
 I wonder, were you lifted,
Did you meet Him?
 How I wish I might
 meet you, Mother Teresa,
 at the end of my sojourn
 on Earth,
For it is wise to keep the company
 of the Saintly.

If I had started
with you, in India,
My Mother T, as orphan,
 I would be much
happier, sweeter, and
lighter than I am today.

In your face, I see my
sister, my mother,
 all mothers true~
And in your eyes,
 A flashing spirit
and blinding beacon.

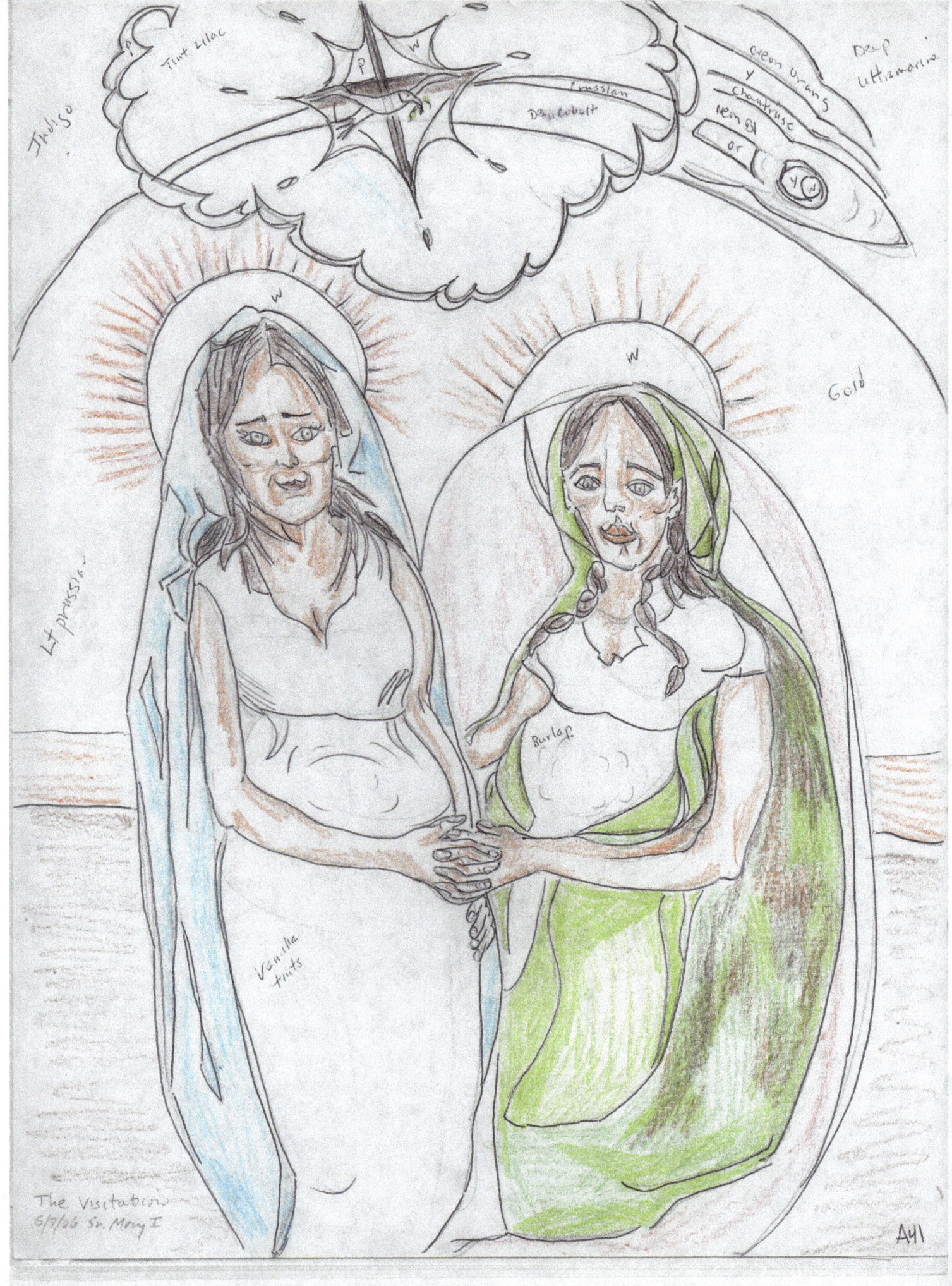

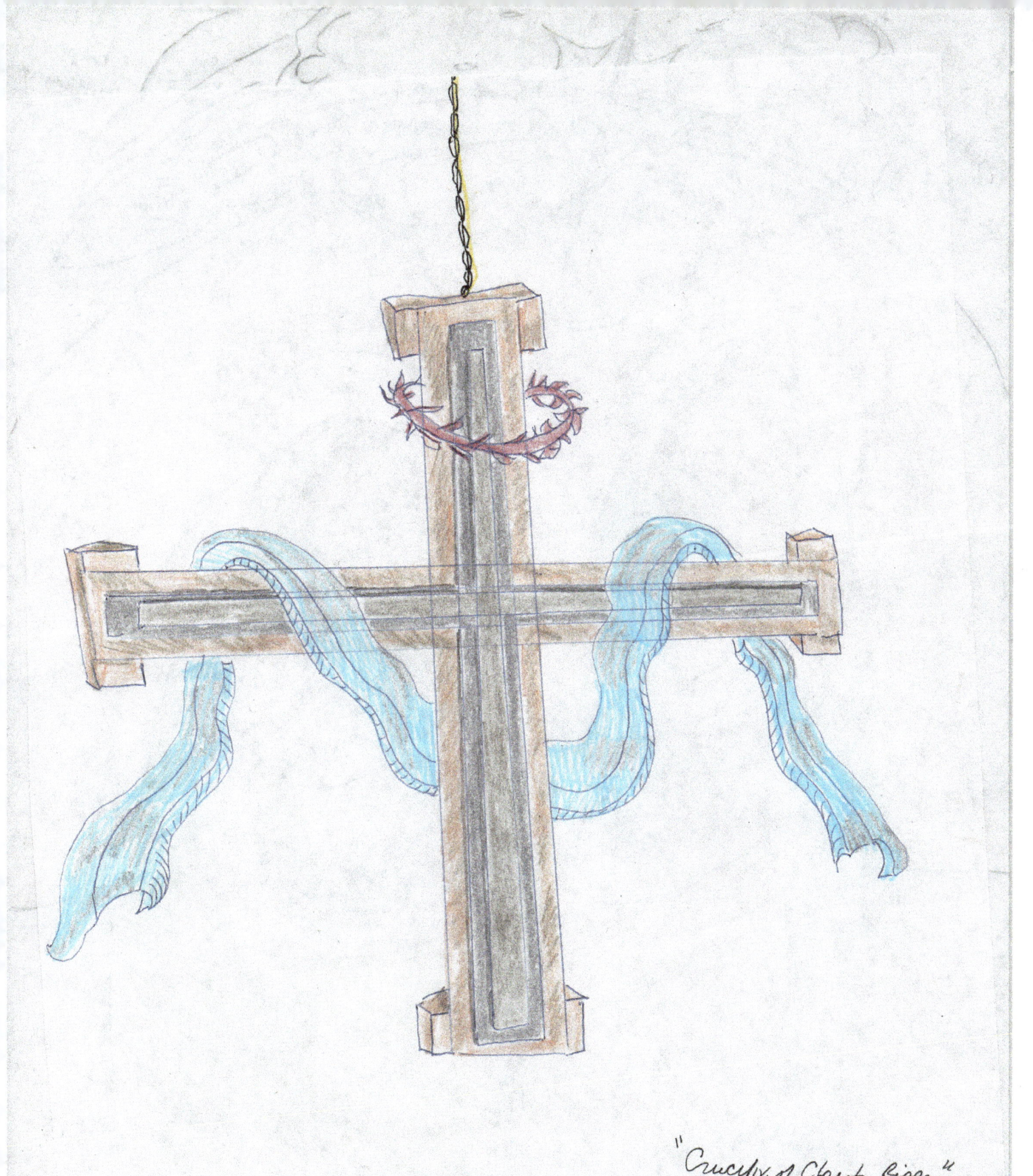

"Crucifix of Christ Risen"
Crucifix Design
for hanging one in the Grotto
of the Church of 4 Apostles
7/27/06 Dr. Monytiere

Gold Silver Bronze
and Cloison Cobalt Enamel

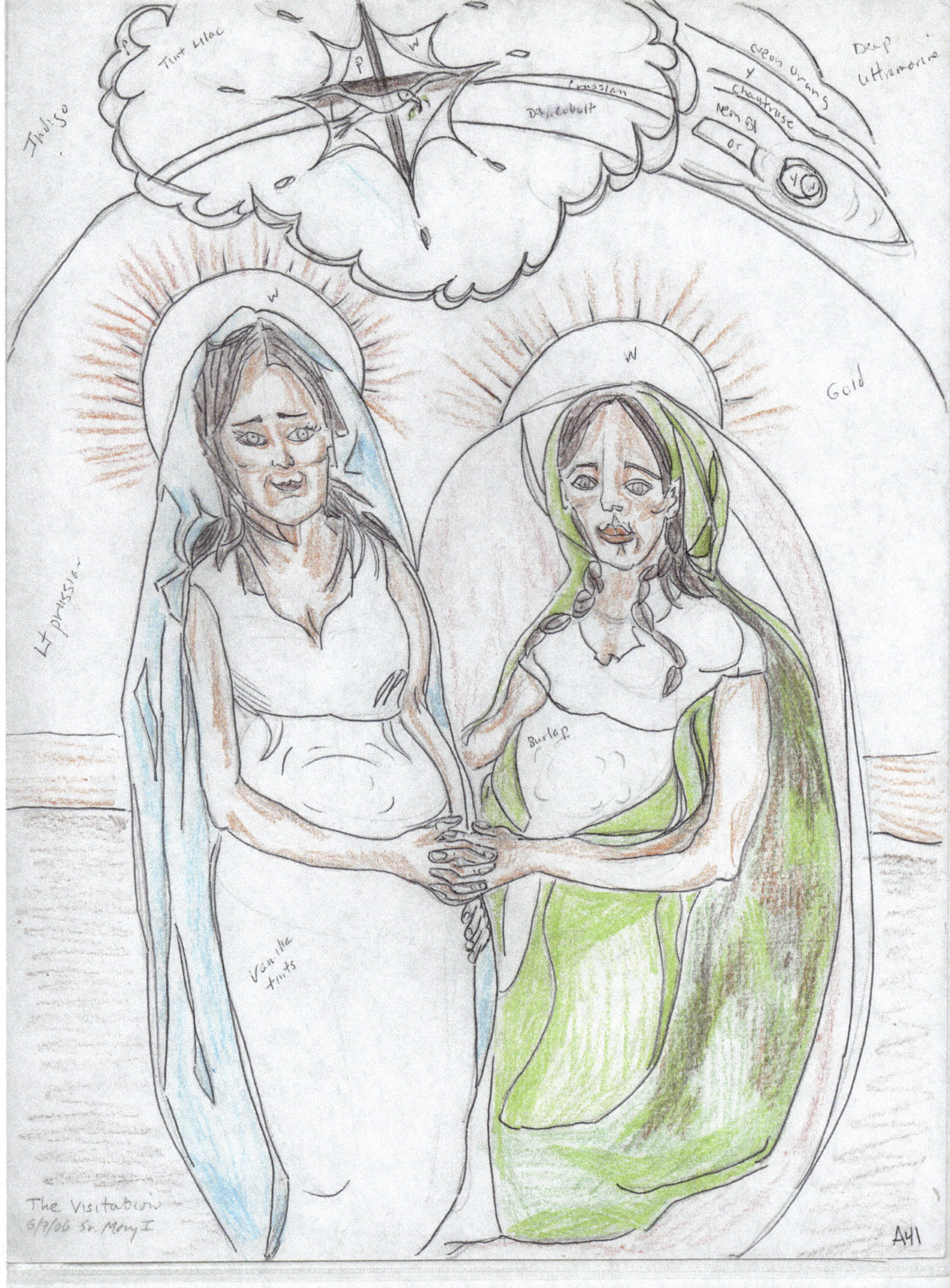

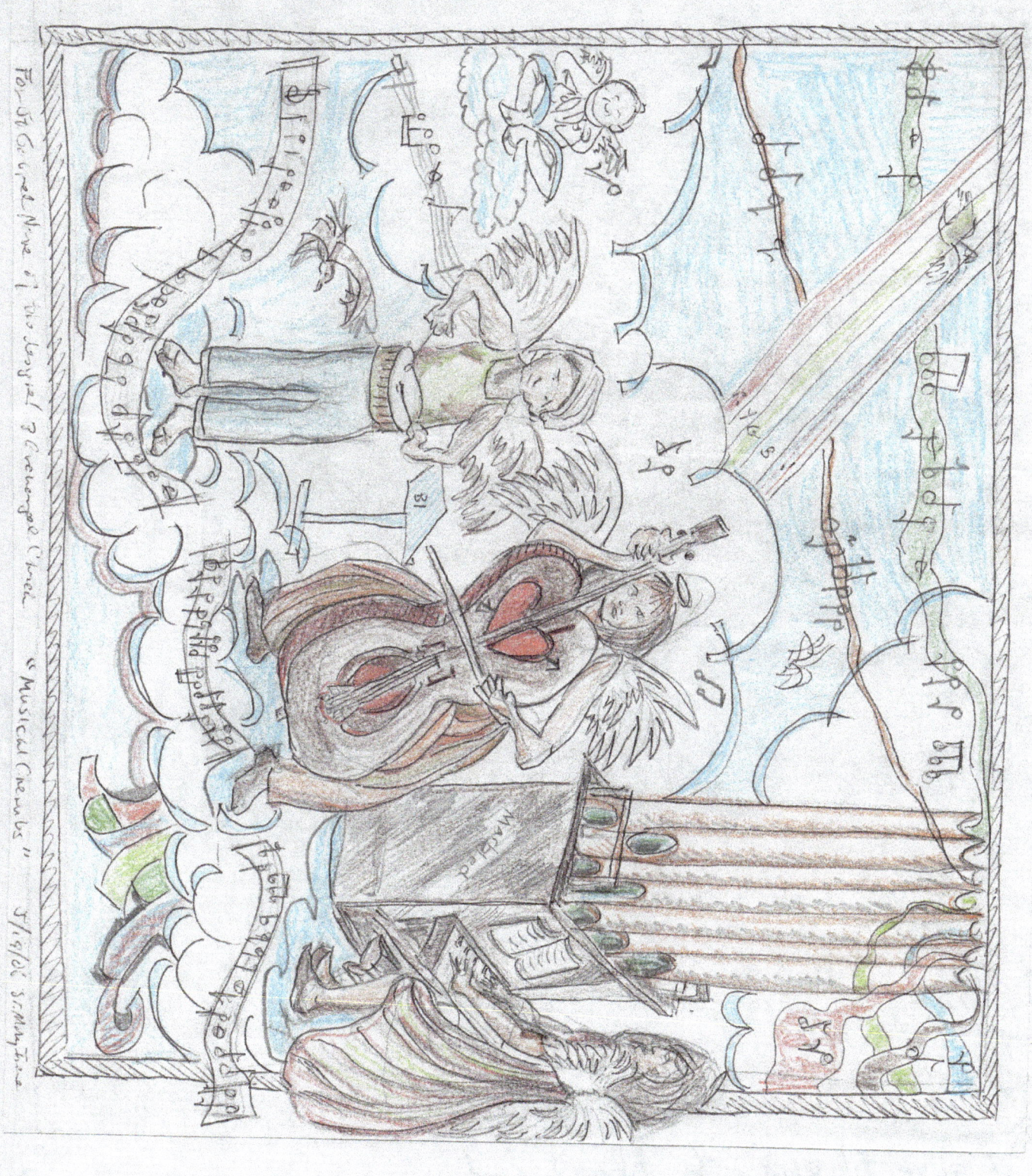

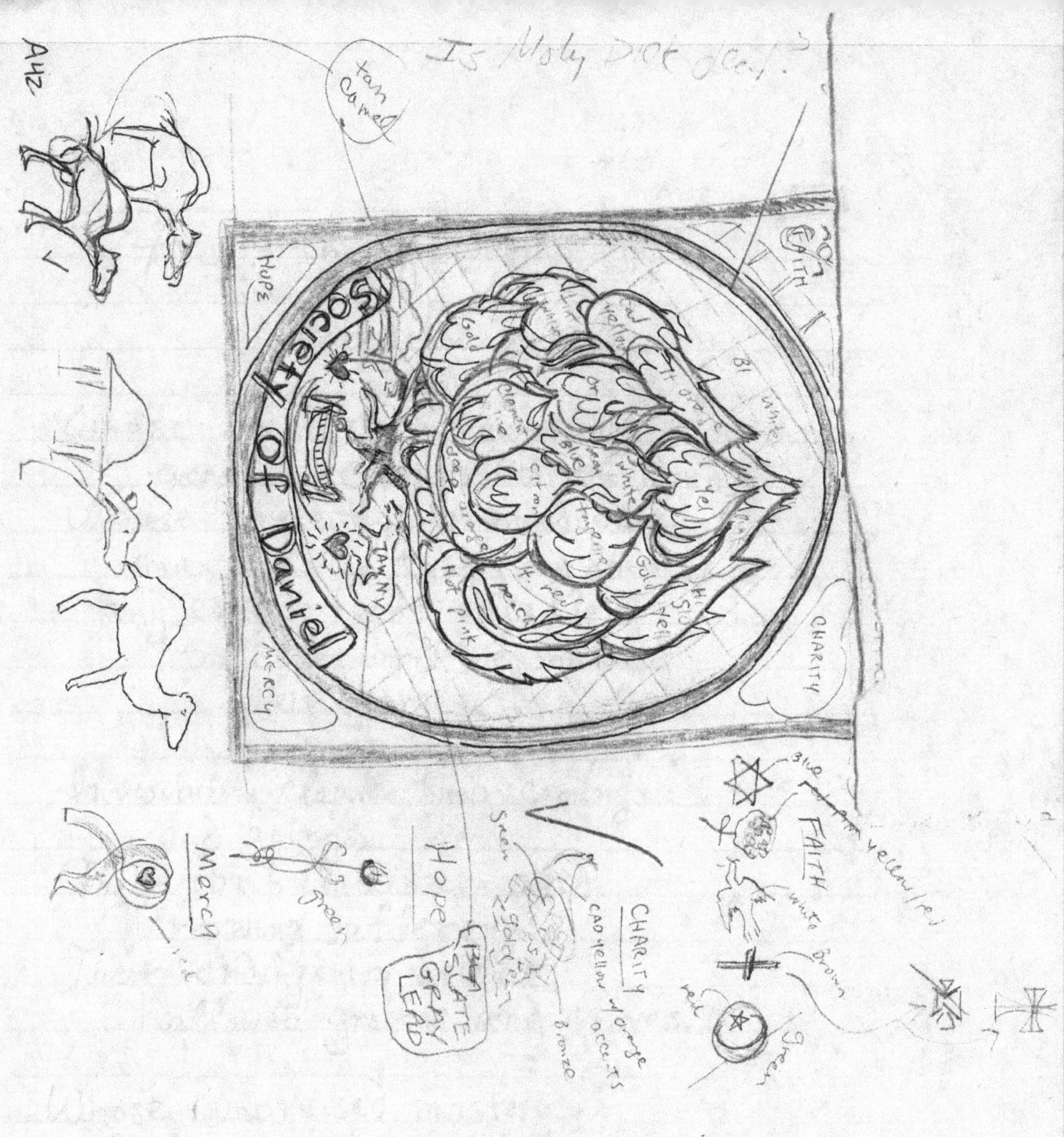

www.ingramcontent.com/pod-product-compliance
Lightning Source LLC
Chambersburg PA
CBHW081015170526
45158CB00010B/3048